# FASHION'S BIG NIGHT OUT

**Kristen Bateman** is a New York City-based writer, editor and creative consultant who specializes in fashion, beauty and culture. She regularly writes for the *New York Times* Style Section, *Vogue*, *Harper's Bazaar*, *W* magazine, *Architectural Digest*, *Elle*, and many other magazines. Her focus is on writing about fashion history, culture and beauty. She also has her own jewellery brand, Dollchunk.

This book is a publication of Welbeck Non-Fiction Limited, part of Welbeck Publishing Group Limited and has not been licensed, approved, sponsored, or endorsed by any person or entity. Any trademark, company name, brand name, registered name and logo are the property of their respected owners and used in this book for reference and review purpose only.

Published in 2024 by Welbeck
An imprint of the Welbeck Publishing Group
Offices in: London – 20 Mortimer Street,
London W1T 3JW &
Sydney – Level 17, 207 Kent St, Sydney NSW 2000 Australia
www.welbeckpublishing.com

Design and layout © Welbeck Non-Fiction Limited 2024
Text © Kristen Bateman 2024

A CIP catalogue for this book is available from the British Library.

ISBN 978-1-80279-804-3

Printed in Dubai

10 9 8 7 6 5 4 3 2 1

# FASHION'S BIG NIGHT OUT

A

LOOKBOOK

KRISTEN BATEMAN

WELBECK

# CONTENTS

# FOREWORD BY JEREMY SCOTT

**Fashion's prom – well, I think that expression doesn't reach the heights of what the Met Gala stands for, or what it means to me. Yes, it's a night out dressed up to the nines and permission to flaunt like a peacock – but it's so much more than that. It's an intersection of pop culture, politics, celebrity, entertainment and fashion, all colliding together for one stellar night out on the iconic steps of the Met.**

I have always had a flair for dressing up – in fact, I don't believe that one can ever be over-dressed for an occasion. You might say it's in my blood. And that is why the Met Gala is one of my most cherished occasions to dress up for, and furthermore, to dress others up in my designs. People always ask: when do you start the planning for the Met Gala? Well, it's the moment the theme is announced, and of course, when your guest is confirmed, as the look has to make sense for the personality wearing it, as well as for the theme and for the designer themself. It's this combination of elements that makes it so dynamic. To capture the moment – as they say, to "understand the assignment" and balance the theme, the celebrated guests and the looks they don. It's become the internet's new form of armchair quarterbacking – fantasy football for fashion-obsessed spectators. But what they don't see are the long hours and hard work that goes on behind the scenes: the multiple sketches and renderings of ideas, the hours upon hours of handwork to create intricate embroideries and beading that dazzle in front of the cameras, the multiple fittings to perfect a moment that is captured in the blink of an eye, with the click of a lens.

6

Having famously created some of the Met Gala's most memorable looks, from a pregnant Cardi B as a religious deity to a barbie-pink Kacey Musgraves, and let us not forget, a chandelier-clad Katy Perry, I can say from experience that there's always a much bigger story behind the scenes than on the red carpet! To this day the chandelier dress is definitely the most complicated dress I've ever constructed: a leather base with a built-in corset to hold not just the sewn-in, chandelier-weight Swarovski crystals, but the entire glass-and-metal armature of a chandelier! Not to mention hiding wires to light up the candle-shaped light bulbs sprouting from said armature! With the dress being so unconventional and unforgiving – I mean, glass doesn't fold – we had to plan for Katy to leave the hotel out of a delivery elevator in a disguise, relocating to a moving truck stationed on a nearby street that was blocked off by police controlling the Met Gala traffic. Katy was then put into the look with the help of my team in a city bus – yes, a city bus! It was the only vehicle with a doorway wide enough (by just a single half-inch). Stress levels were high – one false move and a glass arm could break and that would be all she wrote. We made it to the Met, she descended the bus and we quickly placed the chandelier on her head (it was too tall to wear on the bus). And there she went, my breath fully held until she'd made it the entire length of the stairs – all the way up to the top, like a pro. Without a hitch, Katy Perry pulled off one of the most difficult and iconic red-carpet moments in history.

7

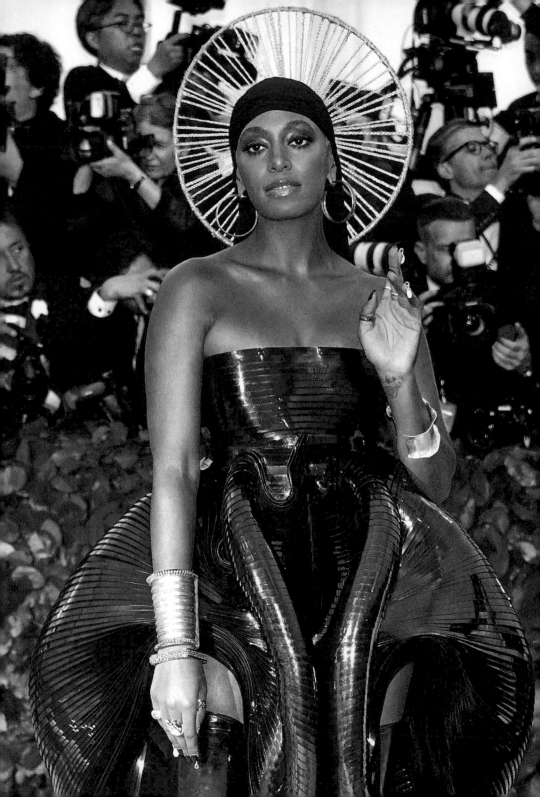

# INTRODUCTION

# A BRIEF INTRODUCTION TO THE MET GALA ...

**Riches! Gossip! Glamour! High fashion and flashing lights! Controversy! Welcome to a one-night fashion event that's talked about far more than any global fashion week, and much more than any other red-carpet event: the Met Gala (also known as the Met Ball).**

On the first Monday in May, each year Anna Wintour, editor-in-chief of American *Vogue*, global chief content officer of Condé Nast, and trustee of The Metropolitan Museum of Art, brings together fashion's brightest stars, the world's most well-known celebrities and the wealthiest philanthropists. They celebrate a night of entertaining and fundraising for The Metropolitan Museum of Art's fashion conservancy called The Costume Institute. Without a doubt, the Met Gala has become the most influential fashion event. It's the only one of its kind on such a scale that so successfully melds art and fashion. Taking place in New York City annually, since 1948, it represents a place where thousands of people take fashion risks and celebrate the art of style.

But why has this once-niche, industry event become seemingly so mainstream? In today's world, the Met Gala allows for the creation of moments and discourse spanning across culture, art and even politics. Think: when Rihanna, one of the most prominent musical artists of the

Previous: Solange wearing an otherworldly gown by designer Iris van Herpen at the 2018 Met Gala.

Opposite: Anna Wintour, reigning queen of the Met Gala.

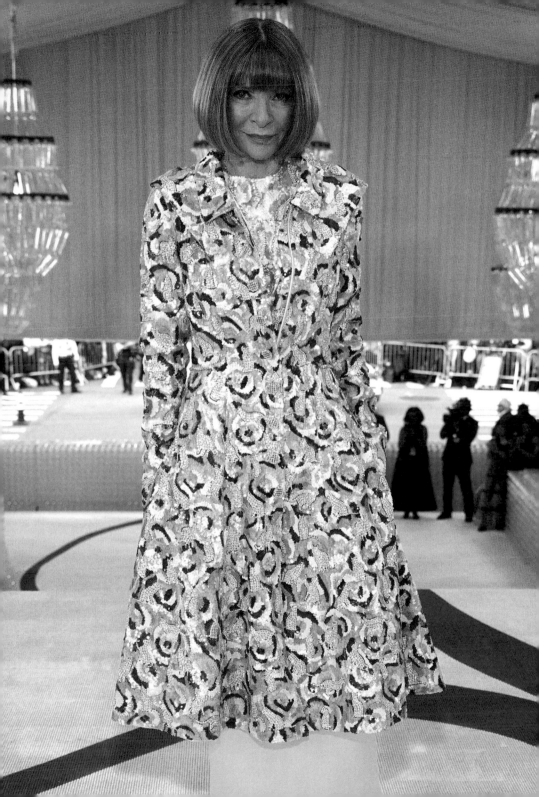

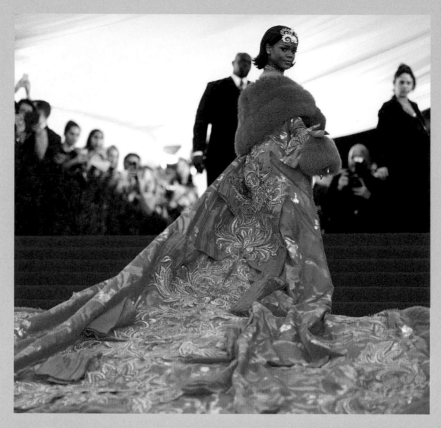

Rihanna's striking gown designed by Guo Pei will go down in history as one of the most incredible Met Gala style choices.

twenty-first century, wore one of the most eye-popping and luxurious gowns of all time to the opening of the 2015 "China: Through the Looking Glass" exhibition. Designed by the Chinese designer Guo Pei, the yellow, fur-lined cape with a 16-foot train was an incredibly dramatic and artful risk that paid off, forever locking the singer into the canon of visionary fashion icons who have become the most anticipated doyennes at the event. Plus, Rihanna's gown also inspired an endless stream of memes, most infamous of all, perhaps, being an image of herself standing in a frying pan with an egg (the dress).

Who could forget the controversial moment created by U.S. Representative Alexandria Ocasio-Cortez,

who wore a Brother Vellies white tulle gown covered with the graffitied words "Tax the Rich" to the star-studded, so obviously ostentatious Gala in September 2021? Making it all the more debatable, in 2023, the *New York Times* reported that congressional investigators had found "substantial reason to believe" that she might have violated House ethics rules and perhaps federal law by accepting gifts associated with the event. No matter which way you look at it, the Met Gala is always going to create some kind of conversation revolving around fashion, art, culture and politics.

And there's this: the supremely striking imagery, dazzling array of A-list celebrity names and host of designer cameos make the Met Gala interesting even for the average Joe who doesn't consider themselves deeply vested in the following of fashion. The Met Gala is a dazzling event that dominates media coverage and brings some of the biggest celebrities and brands together globally, but at its heart, it's a fundraiser. It raises millions for The Costume Institute at the Met ($17.4 million in 2022, and almost $22 million in 2023 – a record for the event).

Beyond that, the *Guardian* reported that the Met Gala generates more "media impact value" than the Super Bowl. In 2019, former Louis Vuitton chairman and chief executive, Michael Burke, was quoted as calling the Met Gala "the pinnacle of our business". In an era when fashion magazines are losing readership and advertisement partners at an alarming rate, the Met Gala has created a sort of massive cottage industry surrounding all the fanfare. Globally, all the major magazines and newspapers cover the event, many sending reporters and photographers for live coverage. The major tech players, like Instagram, host content parties to inspire coverage of the event. And it's all over the news and plastered across our TV screens. The fact that those who may not even value the fashion industry in their daily lives tune into the Met Gala's red carpet and attend the annual accompanying exhibition is impressive, and the numbers show it. *Vogue Business* reported that in the seven days following 2023's

Met Gala, video views, site traffic and social media all saw record highs for engagement across *Vogue* channels.

But back to what makes the Met Gala so interesting to us all: it's a risk-taking event. It's about the confluence of art and fashion, despite all the big business behind it. Celebrities and their fashion counterparts go all out. It's not a typical red-carpet event, where beautiful gowns and conventionally stunning hair and make-up are the norm and expected. People – or at least, some of the most anticipated stars of the night – experiment, pushing the boundaries of what's considered fashion and what's considered art.

This is an event that carries a lot of weight when it comes to clothing and how we look at it. The Costume Institute is one of the first spaces to display fashion as artwork to such a large audience. The Costume Institute's 2018 exhibition "Heavenly Bodies: Fashion and the Catholic Imagination" saw 1.6 million visitors, ranking first among The Met's most-visited exhibitions. The Costume Institute encompasses over 33,000 objects

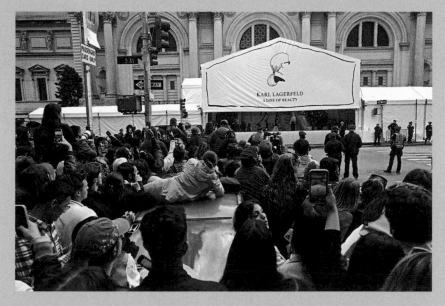

The scene before the Met Gala: fans camp out for hours for the chance to see their favourite celebrities.

representing seven centuries of clothing and accessories for men, women and children, from the fifteenth century to our current times. Historically, clothing has not been looked at as artwork, but rather, looked down upon as decorative arts. And while the Met Gala may be ultra-exclusive, anyone can attend The Costume Institute's exhibition in the days following the Met Gala, as the exhibitions are usually open for a few months at a time. There, clothing is displayed and articulated so creatively, it can change one's entire point of view and the way one looks at fashion as an art form. And it's not just clothing, after all – it's lighting, sound and immersive environments!

What makes the fashion at the Met Gala just so unique is due in part to the theme. This encourages lavish experimentation. Each year, a theme and dress code are decided for the Met Gala, which are based upon The Costume Institute's exhibition for the year. The exhibitions are often thought-provoking, and that's entirely intentional. Andrew Bolton, Wendy Yu Curator in Charge, The Costume Institute at the Metropolitan Museum of Art New York, told *Vogue France* in 2020, "I think every exhibition should generate debate. I think it's important to stimulate debate and to put ideas out there that are difficult to deal with or seen as problematic. That's the role of any museum: to expand people's ideas about a topic through objects."

The dress code, which echoes the scope of the exhibition, demands risk-taking but also offers flexibility to some of the less adventurous dressers. Take, for example, 2023's dress code, which was noted as simply "in honor of Karl", while the exhibition was titled, "Karl Lagerfeld: A Line of Beauty" and showcased the historic designer's work from his namesake line as well as Chanel, Chloé, Fendi, Patou and Balmain. The themes of the exhibition and the dress code are always reflective of the wider exhibition on display ("PUNK: Chaos to Couture", "Camp: Notes on Fashion" and "Superheroes: Fashion and Fantasy").

15

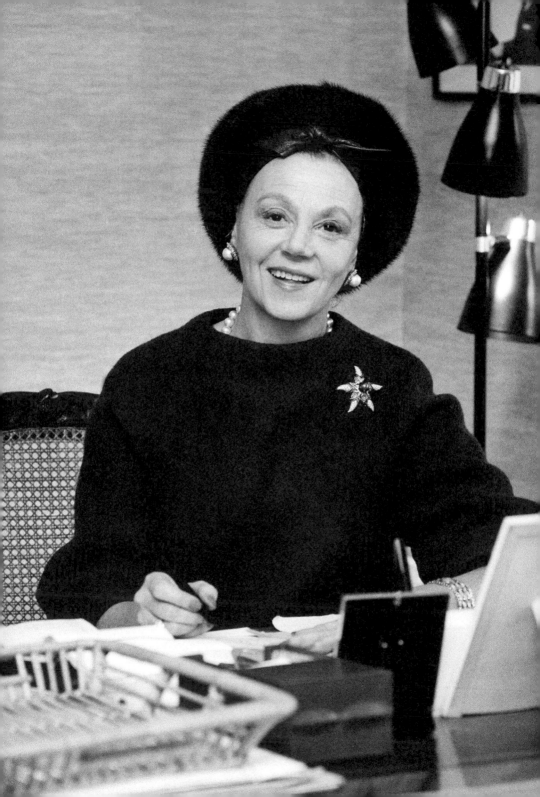

# THE HISTORY ...

# THE BEGINNINGS

**The Met Gala wasn't always the media sensation it is today. In fact, its history goes all the way back to 1948, when its first iteration was hosted in New York City by the fashion public relations queen herself, Eleanor Lambert (1903–2003).**

Famed publicist Lambert made a name for herself, changing the face of fashion with her ingenious press efforts; from creating New York Fashion Week in 1943 to the creation of the International Best-Dressed List (1940), and founding The Council of Fashion Designers of America (CFDA) in 1962.

The sole purpose of the first Met Gala – much like the Met Galas taking place today – was to raise funds for the newly-formed Costume Institute, as well as celebrate the opening of its major annual exhibition. The Costume Institute originally began as the Museum of Costume Art, an independent entity founded in 1937 and led by theatre director and Neighborhood Playhouse founder Irene Lewisohn. In 1946, with the financial support of the fashion industry, the Museum of Costume Art merged with The Metropolitan Museum of Art and became The Costume Institute. Just two years later, the Met Gala was born. At the time, the collection mainly consisted of stage costumes from Lewisohn and set designer Aline Bernstein's 8,000+ piece collection of Jazz Age costumes that had served as a source of inspiration for countless theatre designers.

In 1948, the Met Gala was known as The Costume Institute Benefit – and rather than a red-carpet event, it served as a midnight dinner that cost charitable guests $50 per ticket. At first, there was no red carpet, no A-list celebrities and no flashing cameras. At the time, the

Previous: Eleanor Lambert, the American fashion publicist behind it all.

Above: A scene from one of the earliest Met Galas, in which people could buy a ticket to attend a dance.

event was more industry-centric, mostly consisting of members of New York high society and the fashion world.

To drum up interest, Lambert titled the first Met Gala "The Party of the Year" on the invitation and it took place inside the legendary Waldorf Astoria hotel on the Upper East Side in December 1948. Unlike the Met Gala of today, when Lambert was in charge, she hosted the event as a sort of roving party that would take place all around New York City in different spots: Central Park, The Rainbow Room and Rockefeller Center to name a few.

During Lambert's time, the event continued to be known as The Party of the Year with its theme and exhibition changing annually to match a new title. For example, in 1952, the Gala was titled "The Midas Ball" and featured a presentation of 14 different models wearing various golden-hued pieces from all over the world, from the eighteenth and nineteenth centuries, all drawn from The Costume Institute's collection. In 1955, the theme was called "The International Whirl" and a fashion show was shown to editors, garment manufacturers and department store executives. Then in 1962, the 15th edition of The Party of the Year was held, with tickets priced at $100. The event was held inside the Imperial Ballroom of the Americana Hotel and the theme was "American Holidays", which included a display of bathing suits and ballgowns designed for New Year's Eve, the Fourth of July and more. Under Lambert's direction, the usual chairmen of the Gala were retail executives. In the case of 1962, for instance, Melvin E. Dawley, president of Lord & Taylor, and Adam Gimbel, president of Saks Fifth Avenue, were co-chairmen. The events were successful, but sparsely reported on by the media at the time.

By 1964, the *New York Times* reported that "fashion is all at industry's gala evening out" and that designers, editors and the wives of store executives attended the ball. By this point in time, The Party of the Year was taking place at its now forever home, The Metropolitan Museum of Art, and a red carpet had been artfully installed for guests to pose and walk along as they strode

20

up Fifth Avenue. About 800 people attended, including editors from *Glamour, Harper's Bazaar* and celebrated models like China Machado (one of the first non-white women to be featured within the pages of an American fashion magazine), all dressed for an Asian inspired theme.

# THE DIANA VREELAND YEARS

Diana Vreeland (1903–1989) was the legendary fashion editor who single-handedly changed the face of the Met Gala with wildly provocative themes and more attention and emphasis on the celebrity side of things. Vreeland began her editorial career in 1936 as columnist for *Harper's Bazaar*, later becoming the magazine's first fashion editor until 1962, when she left to join *Vogue* as editor-in-chief from 1963 until 1971. She joined as special consultant to The Costume Institute from 1972–89, organizing 12 different exhibitions and galas, bringing iconic style

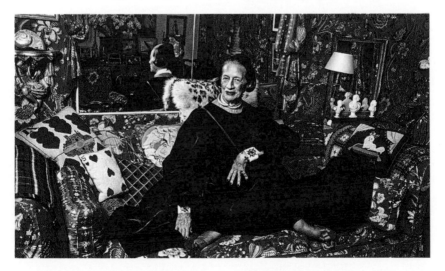

Ever the eccentric, the iconic fashion editor Diana Vreeland had her living room transformed with bold, all-red shapes and prints by interior designer Billy Baldwin.

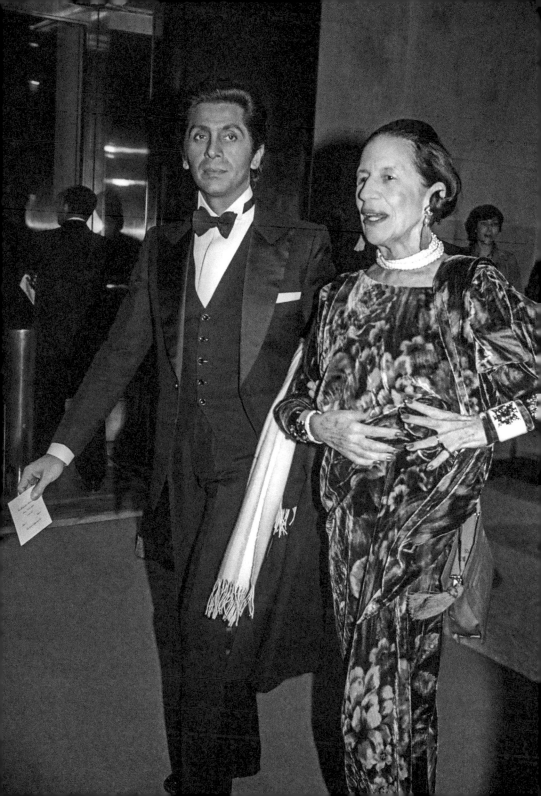

tastemaker Jacqueline Kennedy Onassis and influential socialite Pat Buckley along for the ride as co-chairs.

Buckley also helped shift the focus to a side of the elite social circles of Manhattan. She became well-known for positioning the Gala as having an opulent afterparty, with extremely high ticket prices. These events took place inside the Museum's Great Hall and hundreds of people would party until the sun came up – just to catch a glimpse of the well-heeled guests who were dining at the more exclusive formal dinner.

Vreeland was an eccentric maximalist herself, with her own genre-defying personal style. She didn't just put bold ideas on the pages of her magazines, she lived them. In her work, she prioritized uniqueness and has been credited for bringing youth culture to the editorial landscape. She worked closely with designers such as Bill Blass, Oscar de la Renta, Issey Miyake, Valentino, Gianni Versace and Arnold Scaasi. And for Vreeland, leopard print and scarlet red were the neutral shades of choice. All this and more made her prime for thinking up dazzling and culturally relevant ideas for The Costume Institute. She brought the watchful editor's eye to the event.

Vreeland harnessed her fashion world connections from celebrities to star interior designers like Billy Baldwin, who she hired to transform her own home living room into an entirely red floral fantasy which she dubbed, "a garden in hell". And she invited A-list guests that spanned beyond fashion. Think: Elizabeth Taylor, Liza Minnelli, Diana Ross, Elton John, Cher, Andy Warhol and Bianca Jagger. Such guests, combined with ultra-dramatic settings and distinctively visual themes, meant that the Met Gala became more of The Party that anyone who was anyone wanted to get into – a who's who of society, celebrity and high fashion – rather than merely an industry-only fundraiser evening. The event started to feel more exclusive than ever.

Diana Vreeland attends the Met Gala, dressed with her signature standout accessories.

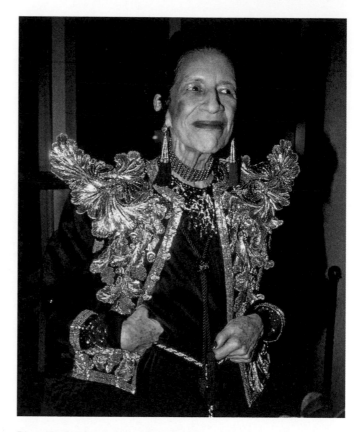

Diana Vreeland attends the 1980 Met Gala in a dramatic gold and red get-up, with black and red accessories.

24

While under Lambert, The Party of the Year had loose themes, but Vreeland pushed the thematic structure to what it is today, with a dress code, interiors and more to match. She began with "The World of Balenciaga" in 1973, an incredibly topical theme given the designer Cristóbal Balenciaga had passed away a year earlier. What else made it so much more exclusive? The price. From the 1970s to the 1980s, the price of a ticket to the Met Gala was reportedly a little less than $1,000, up from the original $50, according to *Women's Wear Daily*.

By 1983, Vreeland built the Met Gala into the ultimate evening for fashion's elite. With the introduction of an Yves Saint Laurent show, she brought in younger,

newer, bolder names spanning across art, culture, cinema and fashion – as well as the old moneyed Wall Street crowd that served as the main philanthropic demographic in the 1980s.

After Vreeland passed away in 1989, Richard Martin, curator of The Costume Institute at the time, took the helm with the support of Harold Koda, the then-curator-in-chief of The Costume Institute, and began curating the thematic annual exhibitions, which included everything from "Cubism and Fashion" to "Rock Style", his final exhibition before his death in 1999. Koda rejoined the Met in 2000 as curator in charge, then hiring Andrew Bolton in 2002.

In 1995, Anna Wintour – now editor-in-chief of American *Vogue*, and trustee of The Metropolitan Museum of Art – took over as co-chair, overseeing the party ever since (excluding the 1996 and 1998 events). Wintour joined *Vogue* just seven years prior to linking up with the Met.

Yves Saint Laurent with Countess Jacqueline de Ribes and fellow designer Bill Blass at the Met Gala, 1983.

# THE ANNA WINTOUR YEARS

**Wintour's initial approach to changing up the Met Gala represents the closest thing to what we know as the Met Gala today.**

The celebrities, the minor details and the guest list – above all else – are under Wintour's control. The Met Gala serves as an extension of *Vogue*'s creative vision and closely reflects the pages of the magazine. "She and her team exert significant control over the guest list, the seating plan, the coverage – deciding which reporters are allowed to go where – and, often, even what selected guests will wear," wrote Vanessa Friedman for the *New York Times* in 2015. During any night at the annual event, you'll see almost every single *Vogue* employee working behind the scenes, from handling seating to standing guard at the halls of the museum.

Under Wintour's guise as editor-in-chief, she shifted *Vogue* covers away from featuring models to focus on A-list celebrities. Other magazines soon followed, as there was now little public interest in models due to *Vogue*'s decision. Frequently, since 2003, the Met Gala has elected celebrities as hosts for its event. It's no coincidence that almost all the past co-hosts have been *Vogue* cover stars multiple times. Just look at Blake Lively, Nicole Kidman and Carey Mulligan, for instance. "There was never an idea that *Vogue* was an editorial project alone," Sally Singer, who worked for Wintour for nearly 20 years, has said. "It was an intervention into the fashion world."

Anna Wintour, the ultimate Met Gala power player, attends the Metropolitan Museum of Art's Costume Institute opening party gala for the "Haute Couture" exhibition on 4 December 1995.

Wintour also made the decision to move the Met Gala to early May. Previously, the event had been held in November or December. Capitalizing on a spring date that has been cheerfully dubbed "The First Monday in May" has made a lasting impression. She has also installed a core team of people who have become her go-tos for the event, like event designer Raúl Àvila, who has been officially responsible for the design of the event since 2007. He's done everything including creating a massive porcelain ginger jar out of thousands of blue and white roses to beautifying The Met's famous stairs with a bamboo forest.

Wintour also spearheaded the A-list performers that guests have now come to expect after the dinner. Think: Cher, Rihanna and Madonna, each of whom has the responsibility of performing, but also bringing their most extravagantly boundary-pushing fashion choices to the museum too. Take, for instance, when Madonna

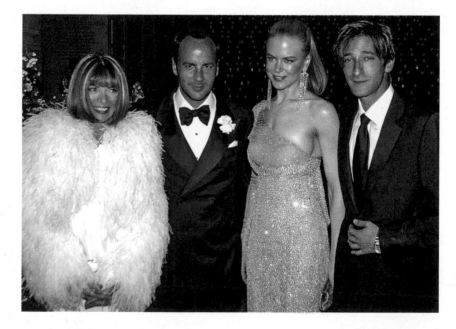

Anna Wintour often poses with co-hosts, such as Tom Ford and Nicole Kidman seen here, and other guests, like Adrien Brody (right) throughout the night.

performed in an ecclesiastical robe alongside monk-like figures in 2018. Wintour sees guests as well as the seating charts at the tables as an opportunity – often brokering relationships with designers, retailers, executives and smaller brands who may not necessarily have the means to purchase a ticket themselves.

And then there's also the price increase of tickets, which has skyrocketed under Wintour's reign: by 1998, the cost of a single ticket rose to $2,000. Three years later, it was $3,500 and today, one ticket is estimated to cost as much as $50,000, or you can buy a table for ten for $250,000, according to *Women's Wear Daily*, in 2023. But not just anyone can get in. Each person on the guest list must be approved by the event's chairwoman: Wintour. And there are numerous stories of people being rejected. To make it all the more interesting, the event has a strict no-social media policy, though some celebrities often sneak in a few photos, especially in the bathrooms. These moments frequently go viral. One example is when Jennifer Lopez accidentally walked in on Katy Perry changing into her cheeseburger outfit designed by creative director Jeremy Scott for Moschino in 2019.

Upon curator Koda's retirement in January 2016, Bolton became curator in charge, known for many of the boundary-breaking exhibitions that broke records. Take, for instance, the aforementioned "Heavenly Bodies" show.

Under Wintour's direction, the Met Gala has become a cultural fixture and an iconic New York City event that is regarded on a global scale. The biggest names in the world – Kim Kardashian, Rihanna, Madonna and more – come together to create thought-provoking statements about fashion and challenge the ideas of fashion and art.

What is art, what is fashion, and when the two combine, is it costume, or something else entirely? The Met Gala is a pathway to discourse as much as a red-carpet spectacular. This is, without a doubt, so much more than the world's most exclusive fashion event.

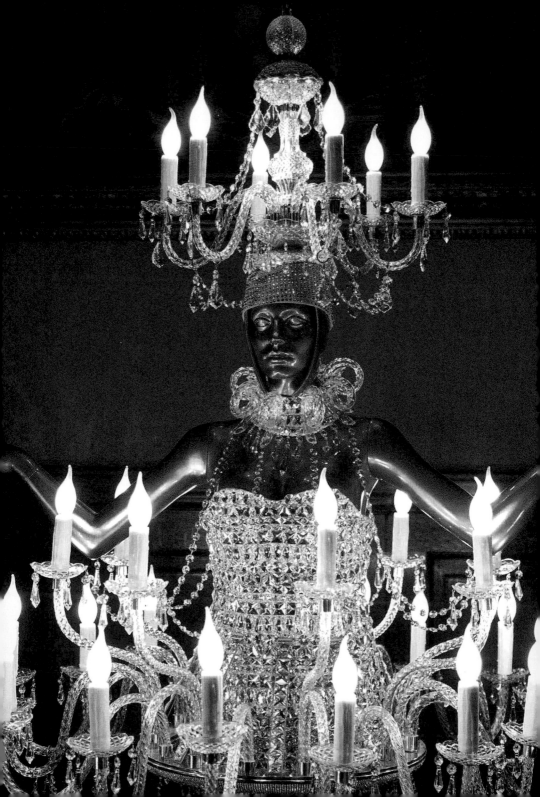

# THE
# EXHIBITIONS ...

# MET GALA: THE COSTUME INSTITUTE

**The Met Gala would be nothing without its themes. After all, the entire purpose of the event is to raise money for The Costume Institute. Each year, The Costume Institute decides on one exhibition theme for the Met Gala.**

Behind it all is Andrew Bolton, The Costume Institute's chief curator. Since its inception in 1948, the Gala has had an exhibition theme, but thematic ideas became more publicized when Diana Vreeland joined The Costume Institute, with her first foray known as "The World of Balenciaga" in 1973. The exhibition serves as the topic for the Gala as well as inspiration for the dress code for the big night out. And these aren't just any fashion exhibitions: most of the time, they include soundscapes, incredibly rich buildouts with sets, custom mannequins and other details that make the experience feel fully immersive.

32

"What I try to do is work on a topic that seems timely, and that defines a cultural shift that's happening or is about to happen," Bolton told *Vogue France*. "We always try to have a menu of shows that are dynamic, that go back and forth on subjects from the past and the present, between thematic shows and monographic ones of a single designer. We try to mix it up."

Previous: Katy Perry's chandelier outfit designed by Jeremy Scott for Moschino, which she wore for the 2019 Met Gala was later put on display.

Opposite: Guests often curate their outfit for the exhibition opening at the Gala – or choose something risky or controversial, like U.S. Representative Alexandria Ocasio-Cortez.

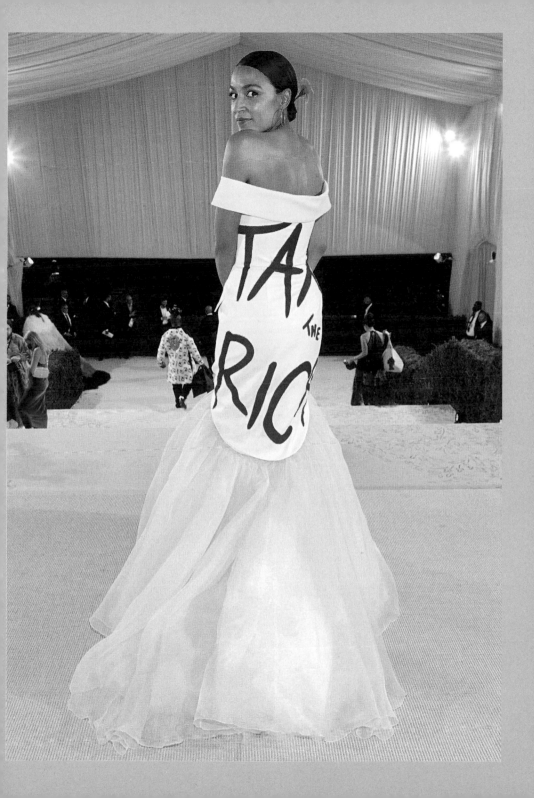

Under Bolton, some of The Costume Institute shows have become the most-visited Met exhibitions of all time. Some of The Costume Institute's most popular exhibitions include "Heavenly Bodies" (2018), "Alexander McQueen: Savage Beauty" (2011), "China: Through the Looking Glass" (2015), "Manus x Machina: Fashion in an Age of Technology" (2016) and "Camp: Notes on Fashion" (2019).

The selection of the theme usually happens about a year in advance, with the team working over the next 12 months to collect, curate and design the exhibition. The exhibition is then typically announced in the fall at a conference during Paris Fashion Week, but usually years of research go into each exhibition and the museum's top players as well as Anna Wintour, need to sign off.

Exhibition themes don't always translate so literally to the Gala dress code either. Take, for instance, in 2014, when the Charles James "Beyond Fashion" exhibit was curated. Wintour decided that male Gala attendees should wear "white tie and decorations".

At its heart, behind the gaze of all the glamour and the red-carpet moments, the Met Gala supports the research and conservation of fashion. And while visitors to The Met's Costume Institute may only see the glittering galleries, there's a lot more that goes on behind the scenes. Take, for instance, a state-of-the-art costume conservation laboratory, a storage facility to house The Costume Institute and Brooklyn Museum Costume Collection, and The Irene Lewisohn Costume Reference Library, which is known to be one of the world's foremost fashion libraries.

The exhibition on America's first couturier, designer Charles James (1906–1978) in 2014 proved to be an interesting challenge for conservation efforts. After all, James is best known for his extremely sculptural dresses, most of which are strapless with large, structured skirts. Keeping the gowns in flat storage made them collapse and lose their structure – but hanging them also caused deterioration, since these dresses weighed up to

34

20 pounds each. The best way to preserve the integrity of the design was to have them on the human form. The solution? The team 3D-scanned the forms used in the 2014 exhibition as well as James's original forms to produce replicas, which were carved from archival foam via a machine, creating a proxy for the human body to beautifully support the dresses. They were then padded with polyester batting and covered in cotton to protect the pieces even more.

Unlike fine art, fashion has always existed to be consumed and that's why these conservation efforts are so important. Longevity isn't always at the forefront of the minds of designers who are creating beautiful gowns or whimsical eccentric pieces that toe the line between clothing and art.

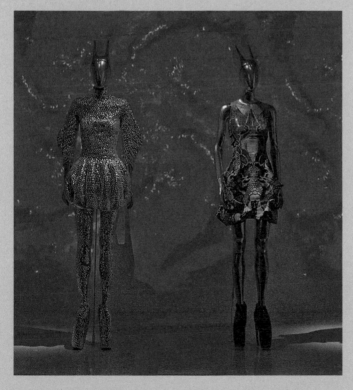

Dramatic and wild dresses from the Alexander McQueen show at The Costume Institute, one of the most-visited shows at the Met.

# THE WORLD OF BALENCIAGA 1973

**Few designers have the influence of Cristóbal Balenciaga and when Diana Vreeland joined The Costume Institute in the early 1970s, she selected the designer for the first big thematic debut.**

The who's who of fashion insiders attended the Gala and the opening exhibition, including Roy Halston Frowick and Calvin Klein. The exhibition followed a similar format to those seen today – evening dresses from Balenciaga's first collection in 1938 up to the wedding dress he came out of retirement to make in 1972, just before he died, for Doña Maria de Carmen Martinez-Bordiú, Duchess of Cádiz, General Franco's granddaughter. This marked the first Met Gala theme solely devoted to one designer, something that would be seen repeatedly throughout the ages. "People would tell me fashion started in the streets, and I would say I always saw it first at Balenciaga," Vreeland told the *New York Times*.

Cristóbal Balenciaga's work brought together the dramatic aesthetics and colours of his home country, Spain. He was often called a master of tailoring and explored grand silhouettes with voluminous shapes. Lace! Ribbon! Taffeta! The rooms of the museum were filled with festive cocoons of fabric that spoke volumes about the work of a designer who changed the world with his striking gowns and colourful creations.

The big volumes and striking shapes of Cristóbal Balenciaga were showcased in the 1973 exhibition, "The World of Balenciaga".

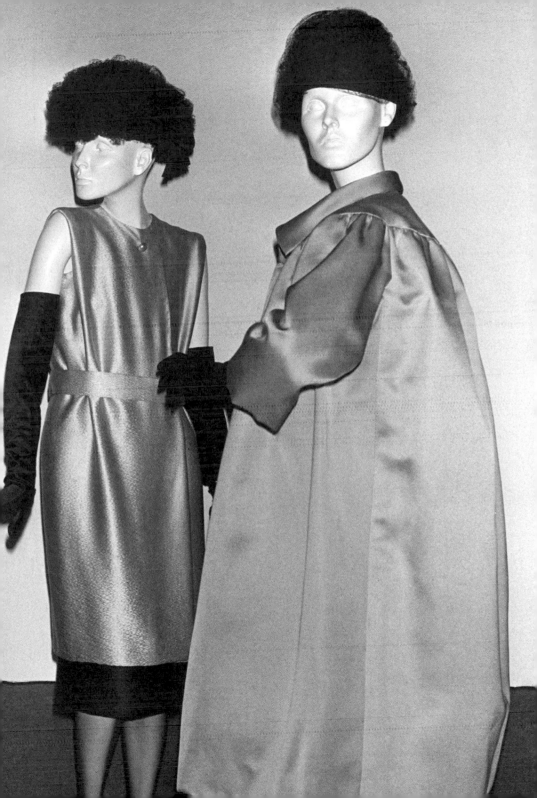

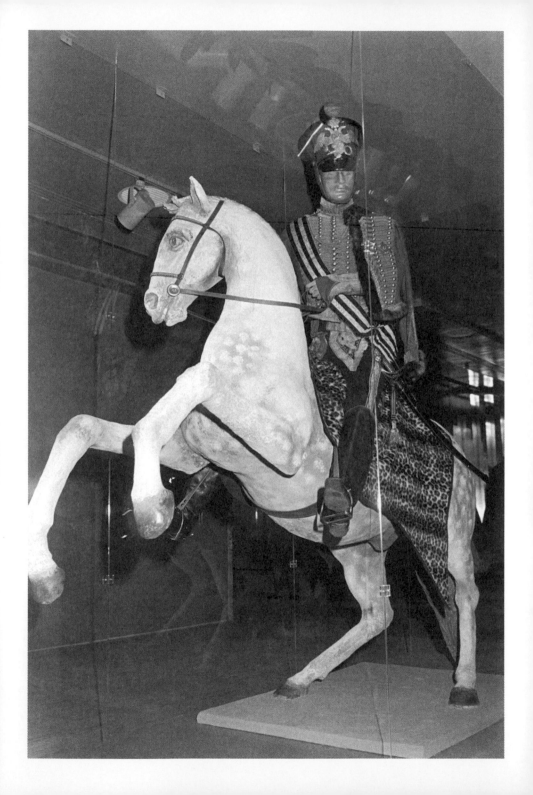

# THE GLORY OF RUSSIAN COSTUME 1976

**By 1976, Vreeland was persuading A-list celebrities to co-host the event. More than 650 people paid $150 each for the 1976 Met Gala reception and dinner at the museum, as Jacqueline Kennedy Onassis served as chairwoman.**

Then, there were also about 1,000 people who arrived after the dinner to see the exhibition, paying $40 each to get in. Onassis opted for a ruffled black, off-the-shoulder dress by the American designer Mary McFadden. French aristocrat and designer Jacqueline de Ribes wore a tiered taffeta dress from Yves Saint Laurent's iconic Russian peasant collection, while socialites C.Z. Guest and Lee Radziwill dressed in a similar aesthetic. And while the exhibition showcased the influence of the Russian aesthetic on Western clothing, as seen in Charles Frederick Worth, there were also costumes never before seen outside the former Soviet Union.

Traditional costumes and uniforms were juxtaposed with brilliant paintings to inspire historical comparisons between the two. The show was unique in that it displayed 100 looks plus accessories representing over 200 years of Russian history from 1700 to 1900. Alongside this, archaeological artefacts and jewellery from the eleventh and twelfth centuries made an appearance.

A scene from "The Glory of Russian Costume" exhibition, in which outfits and uniforms were juxtaposed.

39

# LA BELLE ÉPOQUE
# 1982

**By 1982, Diana Vreeland and her team had taken the idea of the Met Gala to a new place of opulence: one that was at once fantastically decadent and transportive.**

The designer Pierre Cardin pitched in more than $500,000 for the recreation of the interior of the famous Paris restaurant Maxim's (from the Belle Époque era, of course) inside the Met. "Don't forget that the Belle Époque was the culmination of everything having to do with the grandeur of high society, so of course the show is lavish," declared Vreeland. And Halston, Bill Blass, Calvin Klein, Oscar de la Renta, Perry Ellis, Gianni Versace, Paloma Picasso and Raquel Welch were in attendance. Guests paid $500 for dinner and 1,500 others paid $100 each for a dance hosted after the dinner. With over 150 costumes from the likes of Queen Victoria to Lady Curzon, the museum transformed into a lavish affair, with The Great Hall re-designed into a Parisian square with small marble-top café tables, Paris streetlamps, and people in costumes from the Belle Époque era. Also, 20 horse-drawn carriages lined Fifth Avenue.

Inside the museum halls, the mannequins were posed in elegant dance-like positions. Beautifully embroidered gowns displayed great trains. The show captured the spirit of Paris during this very important era, and more importantly, the culture: money, fame, power, class and taste.

The colourful British designer Zandra Rhodes poses with Diana Vreeland at the 1982 Gala.

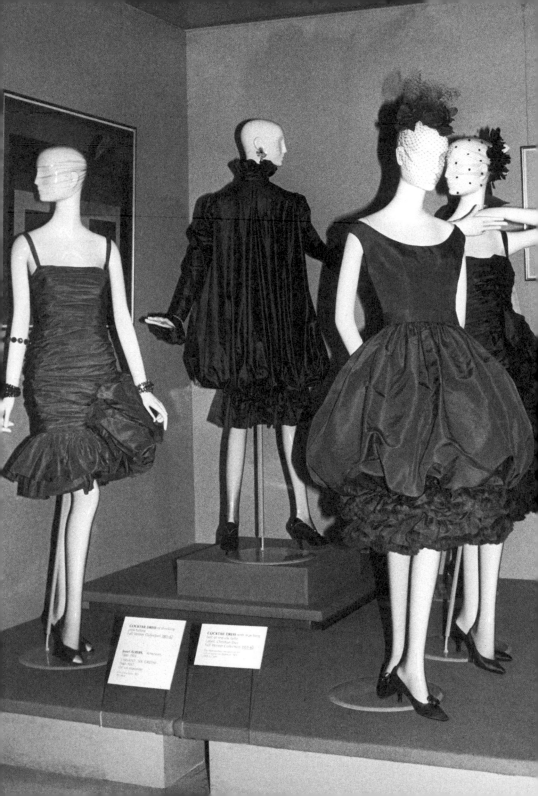

# YVES SAINT LAURENT 25 YEARS OF DESIGN, 1983

**The Yves Saint Laurent theme was unique in that it took on the idea of a retrospective, the first of its kind at The Costume Institute to honour a designer who was still extremely prominent (and not deceased) in the industry.**

All in all, 810 people attended and paid $500 each for dinner. This was also the first time in history that there was such a high demand to attend, and the museum had to refuse 70 more people who wanted to attend the main dinner and many more who hoped to buy a ticket for the after-dinner dance.

The exhibition displayed more than 150 pieces, both couture and ready-to-wear, created by Saint Laurent for his own fashion house, as well as highlights from the collections he designed for the House of Dior from 1957 to 1960. "I don't think of it as an end, but as a beginning,' the designer said, of the exhibition. The colourful rooms were arranged thematically, featuring bold and lush couture gowns as well as some of the designer's most iconic work, such as the series of mini shift dresses painted with primary colours, inspired by the work of the French painter Mondrian. In the exhibition catalogue, Diana Vreeland wrote, "Half of the time he is inspired by the street and half of the time the street gets its style from Yves Saint Laurent." Electrifying colour and print made the case for the public's total infatuation with the designer.

43

The 1983 Yves Saint Laurent show at the Met showcased the designer's decadent silhouettes as well as his penchant for colour and rich textures.

# DIANA VREELAND IMMODERATE STYLE, 1993

**Vreeland was ever iconic in the world of fashion and through her work at the Met Gala up until her death, in 1989, at age 86.**

And so, in 1993, the curators in charge of The Costume Institute staged the annual event in her honour, organized into four different themes representing her work, including "memory", "atavism", "exoticism" and "nature". The show featured imagery of the people Vreeland admired, such as the Duke and Duchess of Windsor, Felicia Bernstein, C.Z. Guest, Yves Saint Laurent and Barbra Streisand. It also featured Vreeland's own clothing: simple and straightforward for daytime and more extreme-leaning for the evening. By this point in time, ticket prices had been raised to $900 and there were over 500 attendees. "Vreeland invented the fashion editor," the legendary photographer Richard Avedon wrote in the exhibition's catalogue. "Before her it was society ladies who put hats on other society editors."

Vreeland had a penchant for costume and a flair for the dramatic, and in this exhibition there were many examples of fashion that mirrored the looks she loved to feature in her editorial shoots. Think: an 1860s Latvian eiderdown coat, an Italian Venetian servant's livery from the late eighteenth century, and splendid Valentino and Mainbocher gowns from the 1970s and 1940s.

44

Guests, like Lynda Carter and Blaine Trump, dressed in leopard print and black lace, signature favourites of Vreeland, during the opening of "Diana Vreeland Immoderate Style" to benefit The Costume Institute.

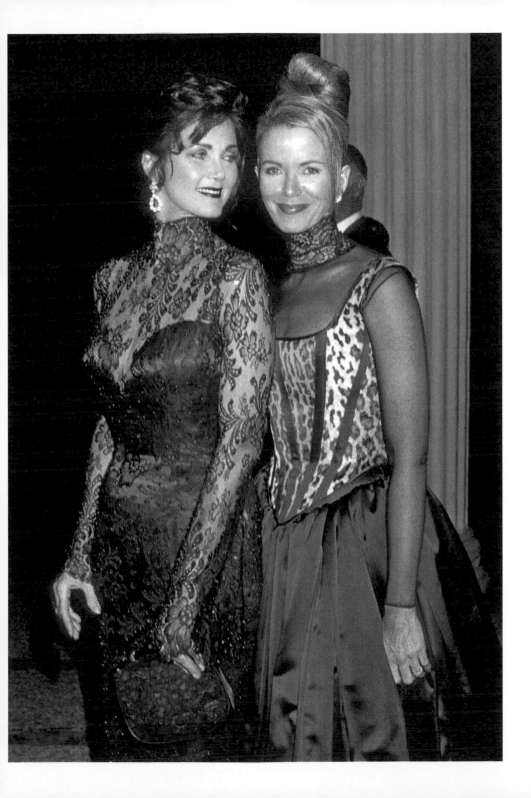

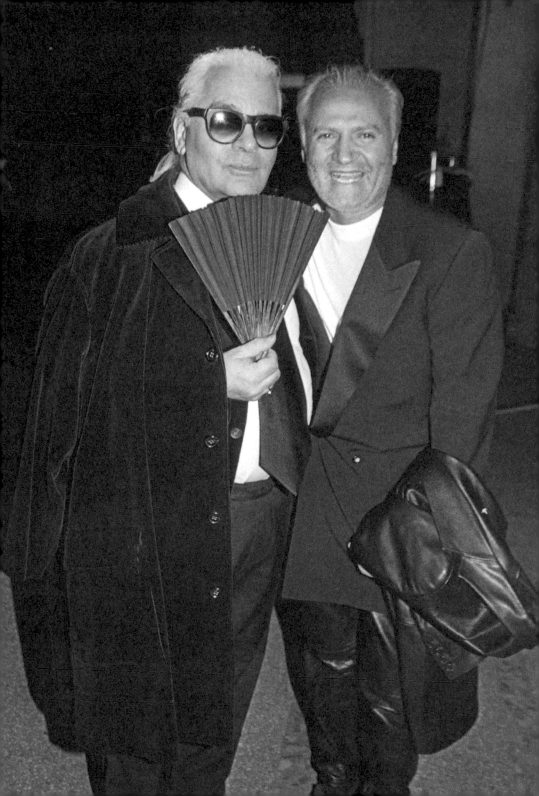

# HAUTE COUTURE 1995

**The year was 1995 and Anna Wintour had taken the helm. The theme of the Met Gala and The Costume Institute's latest exhibition?**

A sort of retrospective of couture's greatest hits – a.k.a. the ultra-elite, handmade highest craft in fashion, everything from Gianni Versace to Coco Chanel, Paul Poiret and more. The event was ultra-fashion focused, with a slew of the most in-demand designers at the time such as Gianfranco Ferré, Christian Lacroix, Oscar de la Renta, Valentino, John Galliano, Gianni Versace and Karl Lagerfeld all in attendance – as well as the industry's top models, including Naomi Campbell, Kate Moss and Christy Turlington.

The exhibition focused on haute couture as it was founded in the 1850s and 1860s. It showcased the master craftsmanship and how couture has stood as the pinnacle of high fashion, setting the standard for the most decadent and high-end fashion in the world for over a century. Behind the glass, garments – from gowns, sweaters, day dresses and structured skirts – were put on display with an emphasis on every single hand-stitched detail. A spotlight was put on embellishment and handiwork.

47

Karl Lagerfeld and Gianni Versace were just a few of the notable who's who of designers in attendance at the 1995 Met Gala.

# CHRISTIAN DIOR
## 1996

**It was the only Met Gala that drew Diana, Princess of Wales from across the pond.**

Dressed by John Galliano, the newly named creative director of Dior, she waltzed throughout the exhibition and dinner, brushing shoulders with virtually every top supermodel as well as A-listers from the fashion industry. The exhibition served as a retrospective of Christian Dior's artistry, but also an intellectual take on how many of the designer's works took inspiration from the past in terms of silhouettes and technical shapes.

The show coincided with the 50th anniversary of the Dior "New Look" silhouette (the narrow-waisted, structured by built-in corseting) of 1947, and showed many examples of the iconic shape that changed fashion as we know it. Over 80 different garments were displayed throughout the venue. Highly decadent and always feminine, the work of Christian Dior was examined through organza and tulle evening gowns, lavish embroidery and opulent black wool suits.

48

## "The waist, the bust, the hips – he knew how to do it."

*John Galliano, then-creative director of Dior, on Christian Dior's work, during the exhibition opening.*

The signature ultra-feminine silhouettes of Christian Dior were placed fully on display through gowns and dresses.

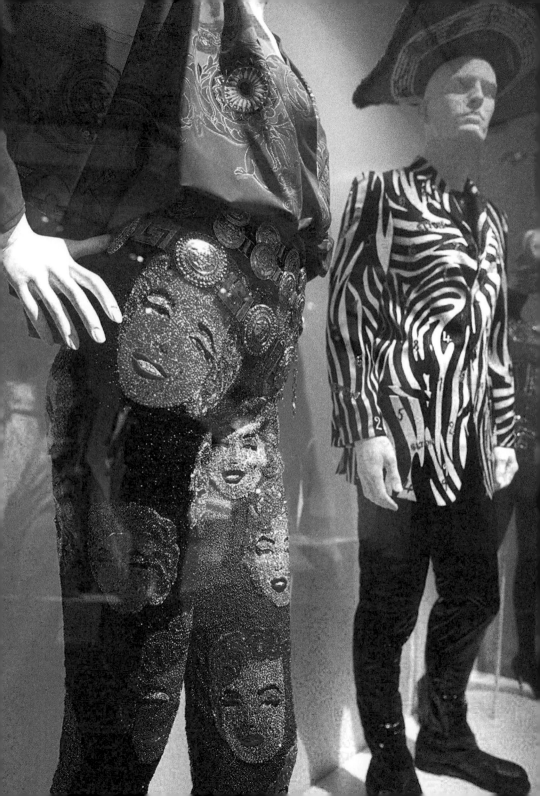

# GIANNI VERSACE
# 1997

**Once 1997 hit, the Met Gala had managed to become an A-list event with a focal point on all things celebrity with an even higher price tag.**

The exhibitions themselves started to incorporate more celebrity into the history of the clothing storytelling. The Italian fashion designer Gianni Versace (1946–1997) had recently been murdered on the doorstep of his Miami mansion and The Costume Institute celebrated his life and work with emphasis on some of the iconic looks worn by the top faces: Madonna, Courtney Love and – who could forget? – the dress seen round the world: the safety-pin dress worn by Elizabeth Hurley when she accompanied Hugh Grant to the premiere of *Four Weddings and a Funeral* in 1994.

The exhibition focused on Versace's later work and gave credit to many of the muses – some who walked the museum halls for the Gala themselves, like Naomi Campbell. "Such is the power of media images, that, abstracted from the celebrity context, the outfits still seem to bear the imprint of their famous wearers – even though the mannequins' faces are wittily wrapped in printed scarves," wrote the acclaimed fashion journalist and critic Suzy Menkes.

Gianni Versace's work had a heavy focus on glamour, and that was showcased through the colourful, deliberately unabashed animal prints, sequins and references to pop art – all on display here.

51

Visually stunning examples of Gianni Versace's work took over the halls of the Met in this exciting exhibition.

# CUBISM AND FASHION
## 1998

**Shifting the theme away from the careers of individual designers, The Costume Institute turned to Cubism as a hot button topic in 1998.**

With Prada at the helm as the sponsor (a great choice, given head designer Miuccia Prada's penchant for geometric prints), the exhibition sought to explore how the fundamental traits of Cubism in art have been translated into fashion. This exhibition also marked 50 years of the Met Gala – and tickets were priced at $2,000 each, with after-dinner dance tickets priced at $200 each. Miuccia Prada greeted guests including Liv Tyler and Alan Cumming.

Perry Ellis sweaters inspired by the work of Sonia Delaunay, Vionnet draped gowns and fantastical creations from Issey Miyake were all present in the exhibition. Print, embellishment and silhouette were contrasted with the concepts and ideas put forward by the artists of the Cubist movement. More than 40 examples of fashion were included and ranged from the beginnings of Cubism in 1908 to the present day. Exploring the work of artists including Picasso, George Braque and Ferdinand Léger as a constant source of inspiration for fashion design, the exhibition contextualized recurring prints, lines and even colours.

52

Mrs Prada served as co-chair of the 1998 Met Gala and was a friendly, welcoming face to many celebs.

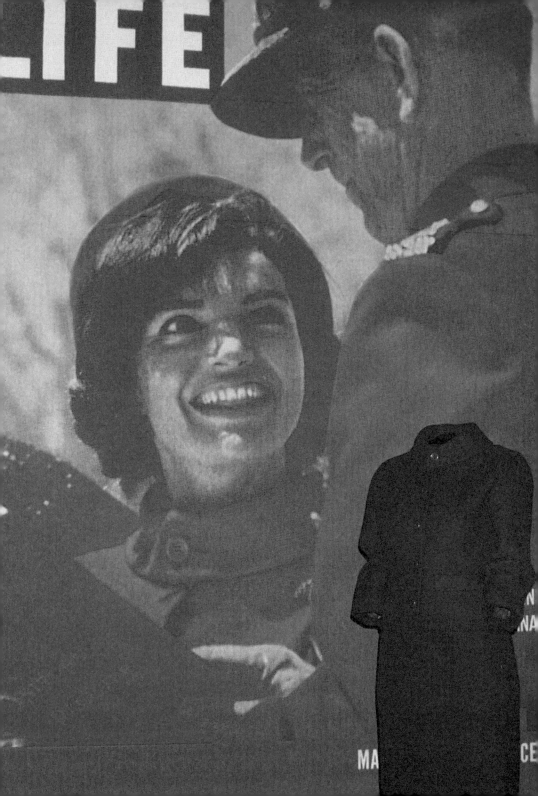

# JACQUELINE KENNEDY THE WHITE HOUSE YEARS, 2001

**Rarely has the Gala turned an eye to style icons in the political sphere, but such is the influence of Jackie Kennedy in the White House and beyond. For the purpose of this exhibition, emphasis was placed on her wardrobe in the White House.**

While Oleg Cassini served as the official designer to Jackie when she was in place as First Lady, she also wore other designers, which guest curator Hamish Bowles spotlighted – from her iconic fawn coat to her signature pillbox hat. Celebrities came out in droves, including Diana Ross, Christy Turlington, Stephanie Seymour and Elle Macpherson, to name a few. The show included 80 original costumes and accessories from her White House wardrobe as well as pieces worn during her husband's 1960 presidential campaign.

So far, it has been the only Met Gala exhibition themed on a political figure, though her influence spans much more than the typical First Lady. Other highlights of the show included the gorgeous ivory satin gown worn to the pre-Inaugural Gala, a red dress worn for the televised tour of the White House, and a large group of formal evening wear worn at the White House for state dinners, political events and cultural gatherings.

55

Former First Lady Jackie O's style impacted the masses and pop culture and this 2001 exhibition celebrating her style showcased some of her most iconic outfits.

# DANGEROUS LIAISONS
## FASHION AND FURNITURE IN THE EIGHTEENTH CENTURY, 2004

**The first Met Gala to combine fashion and interiors on such a grand level happened in 2004.**

Karl Lagerfeld and his muse Amanda Harlech walked through the exhibition juxtaposing eighteenth-century furnishings and rococo fashions between 1750 and 1789, shown in The Wrightsman Galleries, the Museum's French period rooms. Guests such as Linda Evangelista went all out, although many seemed to have a fair amount of difficulty dressing for the theme. Sophie Dahl, Julianne Moore, Diane Kruger and Bernadette Peters opted for more simplistic minimal gowns. "It is just so romantic – when we see the figures in the rooms it makes everything come alive," Anna Wintour told the *New York Times* of the event. "We have never had such an opportunity to do anything so sexy and so real."

The museum created vignettes of mannequins wearing clothing inside the galleries, giving the show an enticing narrative feel. Most exciting was the coquette-like Polonaise dress, shown in contrast next to a side table that transformed into a dressing table through mechanisms similar to the hidden ties of the dress. The Met called the exhibition a "choreography of seduction and erotic play".

The models dressed extravagantly and had some of the best outfits for this theme, for example, Amber Valletta, Natalia Vodianova and Linda Evangelista seen here.

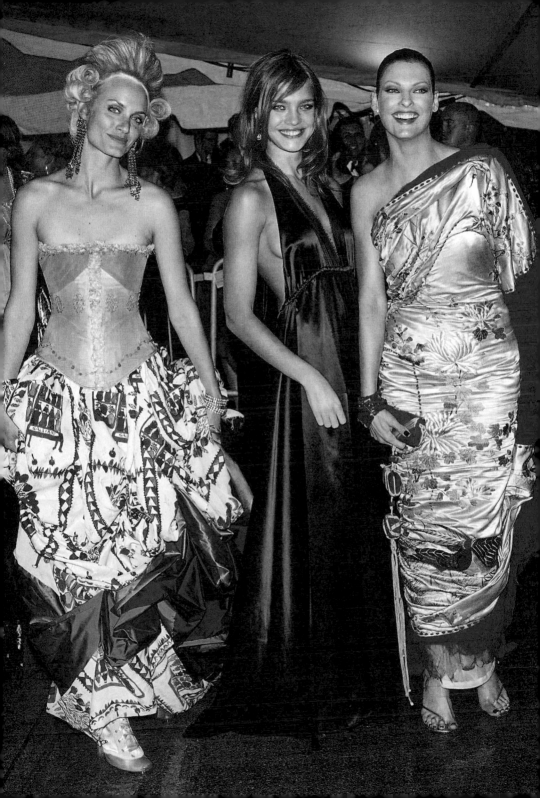

# ANGLOMANIA
## TRADITION AND TRANSGRESSION IN BRITISH FASHION, 2006

**In 2006, The Costume Institute put together its biggest exhibition on the history of British fashion thus far.**

Charting British fashions from 1976 to 2006, the show took place inside the Metropolitan Museum's English period rooms – the Annie Laurie Aitken Galleries – with the intent to create a daring dialogue between past and present. It was organized by Andrew Bolton, the Met's associate curator, with support from Harold Koda, its curator in charge, and the decorative arts curators Ian Wardropper and Daniëlle O. Kisluk-Grosheide. Inside, the museum placed 65 mannequins in the space showing the work of Vivienne Westwood, Hussein Chalayan and Charles Frederick Worth, among others.

Overall, there was an attempt to show the conscious historicism that British fashion has reckoned with through this time period. From utilizing the Union Jack to focusing on native florals, the show emphasized the dichotomy present in contemporary British fashion. Also on view: fashion that reinterpreted landscape paintings, clothing that utilized historical prints and made them ironic, and a handful of old-world gowns styled with dramatic flair. There was absolutely no shortage of accessories here, either.

59

Top hats, dramatic Vivienne Westwood gowns – all the elements of British style were there and then some.

# SUPERHEROES FASHION AND FANTASY, 2008

**What do comic book heroes and their costumes have to do with fashion? A whole lot, as it turns out. All in all, 60 outfits were shown, many of them taken directly from movies.**

The *New York Times* described it as a notable change from the typical Costume Institute exhibition: "The exhibition is a departure from the museum's lavish historical surveys. This is the lighter, more fantastical side of fashion, an industry that loves to talk about the genius of Balenciaga while clamoring to dress the body of Beyoncé," wrote Cathy Horyn. The theme put the spotlight on some of the more unique sides of superhero costumes and designer fashion, contrasting the unitards of Wonder Woman with the lines, silhouette and shape of work by Madeleine Vionnet and Jean Paul Gaultier. Thierry Mugler's metal and armour-like bodysuits were also included.

The costumes of superheroes often have an extreme focus on the body, and all that was displayed here through high-fashion versions. Mirroring perfection, malleability and transformation which fashion so often prizes; the garments included in this show represented that preoccupation. From American flags to capes and accessories done in silver, gold and bronze, it was the dream concept for any comic book fan.

60

Super fashion inspired by a superhero: in this case, Superman served as the inspiration.

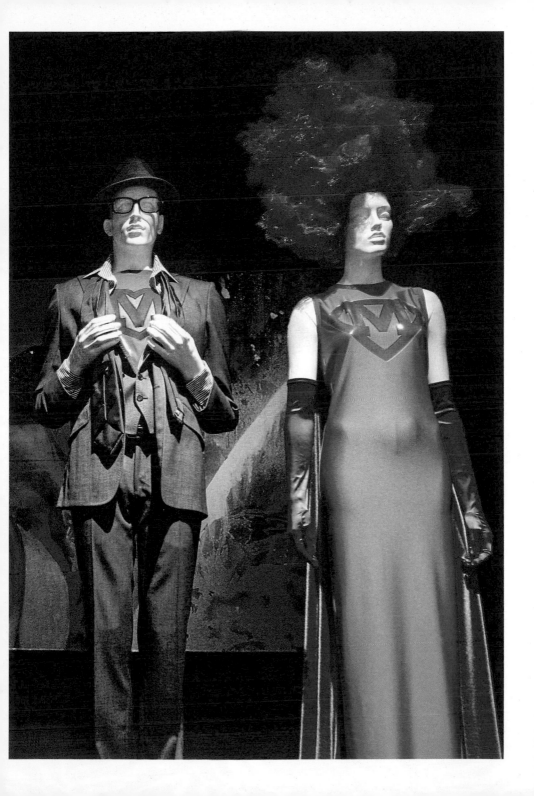

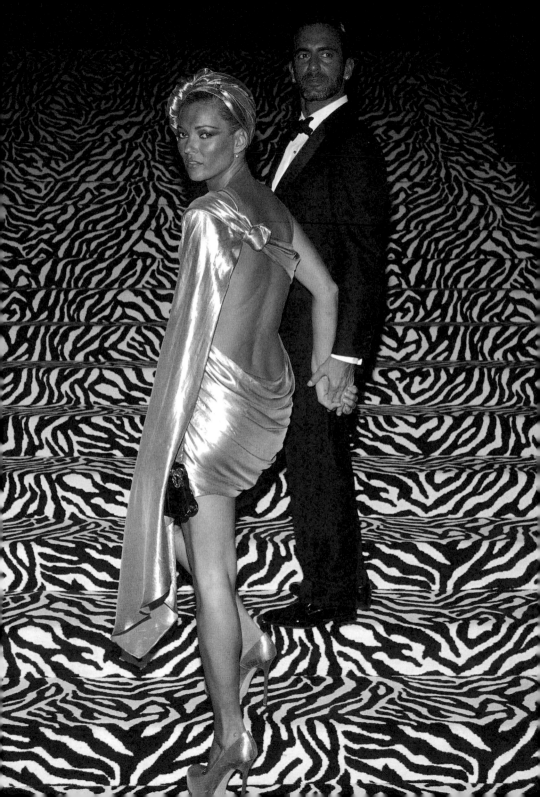

# THE MODEL AS MUSE
# EMBODYING
# FASHION, 2009

**Kate Moss co-hosted the 2009 Gala alongside Marc Jacobs, Anna Wintour and Justin Timberlake. She wore a slinky gold minidress, turban and matching heels by Marc Jacobs.**

Nearly 100 other models attended the Gala and exhibition opening, including the likes of Gisele Bündchen and actress/models Lauren Hutton and Brooke Shields. Seats started at $7,500. The exhibition itself charted models in fashion – in particular, the earliest fashion history of Richard Avedon's portraits of Dovima and Sunny Harnett in the 1950s up to the great supermodels of the 1980s. This year's theme had a hint of controversy too: Stephanie Seymour and Naomi Campbell announced they would not attend, based on complaints from the Paris designer Azzedine Alaïa that his work was not included in the exhibition. Alaïa, for years, had incredibly close and collaborative relationships with many top models throughout their careers. It was also reported that the event was charging up to $250,000 for a prime table that year.

63

Inside the museum's halls, the works on view were organized by historical periods from 1947 to 1997. The fashion on display included both haute couture and ready-to-wear as well as ample amounts of fashion photography and video footage of the models who epitomized the idea of muses throughout time.

Kate Moss with designer Marc Jacobs at the Gala, wearing one of her most iconic outfits of all time.

# ALEXANDER MCQUEEN SAVAGE BEAUTY, 2011

**Some may say "Alexander McQueen: Savage Beauty" is one of the most memorable Costume Institute exhibitions of all time.**

After all, the show brought together some of the most incredible pieces of the designer's career – the sort you rarely get to see up close and in-person. In addition, the museum created surreal, stunning scenes that were elegant and dark – little library spaces, smoky mirrors, cabinet of curiosity style walls displaying pieces. This was the Costume Institute exhibition that really felt like it struck a chord with the mainstream and ignited widespread interest in fashion in a museum context. It ranked among the museum's 20 most popular exhibitions since it began tracking attendance 50 years ago and one of the Met's most attended exhibitions of all time. In all, 661,509 viewers attended and the show was extended twice, also going on to show at London's V&A museum. Many people opted to wear McQueen to the Gala as well, including Naomi Campbell, who wore a silver harness dress that the designer's successor Sarah Burton made for her, and Karen Elson, who chose a silver beaded dress from the Spring 2004 collection based on Sydney Pollack's 1969 psycho-drama, *They Shoot Horses, Don't They?*

64

The fashion in the "Alexander McQueen: Savage Beauty" exhibition of 2011 shocked and delighted museum-goers with its unique point of view.

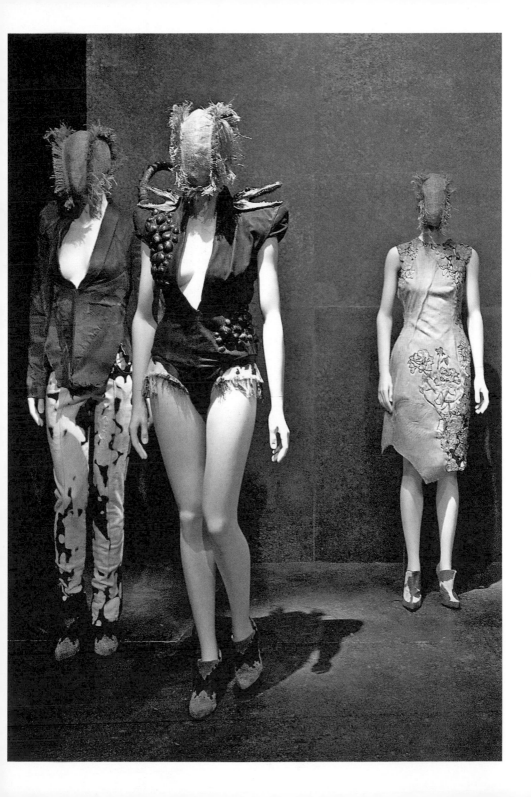

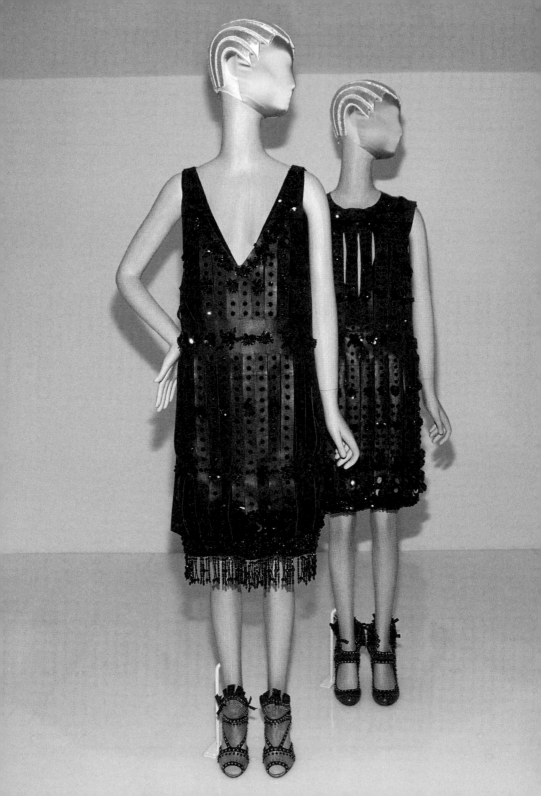

# SCHIAPARELLI AND PRADA
## IMPOSSIBLE CONVERSATIONS, 2012

**One of the most interesting and striking exhibition themes of all time is "Schiaparelli and Prada: Impossible Conversations", in which The Costume Institute made comparisons between the work of Elsa Schiaparelli and Miuccia Prada.**

It was the first exhibition to compare two different designers in one setting. The smaller, tightly edited show displayed pieces that were strikingly similar, yet so vastly different. In all, there were 140 designs and 40 accessories by Schiaparelli (1890–1973) from the late 1920s to the early 1950s and by Prada from the late 1980s to the present day. These were then separated into seven thematic galleries, including "Waist Up/Waist Down", "Ugly Chic", "Hard Chic", "Naïf Chic", "The Classical Body", "The Exotic Body" and "The Surreal Body".

Linking two iconic Italian designers from two very different eras presented an incredibly interesting point of view. The concept was inspired by Miguel Covarrubias's "Impossible Interviews" series for *Vanity Fair* in the 1930s, which led to the exhibition's orchestrated conversations between the two designers. While Schiaparelli was an art-world doyenne who was closely associated with the surrealists, Prada holds a degree in political science and took over her family's Milan-based business in 1978.

67

What do you get when you contrast two of fashion's greatest female intellectual designers? A mind-bending experience that makes you think. Here, some studded leather Prada dresses.

# PUNK CHAOS TO COUTURE, 2013

**The museum's first exhibition to look at subcultures took place in 2013. "PUNK: Chaos to Couture" evaluated the impact of punk's aesthetic on fashion from the early 1970s to current times.**

One hundred different pieces, including original punk garments and designs by fashion houses including Chanel were featured. There was a heavy focus on the underlying narrative of the birth of punk in New York and London as a tale of two cities, as well as of the manifestation of DIY culture through punk fashion. Along with this, the exhibition featured impressive mohawk hairstyles designed by the infamous runway hairstylist Guido Palau amid an immersive multimedia, multisensory experience with a clashing soundscape. The show certainly did its job of showing the cross-cultural influence of clothing and how it played into the music scene. For the occasion, Vivienne Westwood, Debbie Harry and Madonna walked the museum halls. The entrance was decorated with a 40-foot-tall chandelier comprised of thousands of aluminium plates in the shape of razor blades.

Most impressive was the amount of focus that went into the DIY section, a rarity for a fashion-themed museum show. It emphasized the themes of Hardware, Bricolage, Graffiti and Agitprop, and Destroy.

The colourful wigs made by the infamous runway hairstylist Guido Palau added a surprising narrative element to the exhibition.

# CHINA THROUGH THE LOOKING GLASS, 2015

**One of the largest Costume Institute exhibitions of all time was staged in 2015.**

"China: Through the Looking Glass" explored the impact of Chinese aesthetics on Western fashion and how China has fuelled the fashionable imagination for centuries. Over 140 garments were shown, many of which were contrasted with paintings, porcelains, films and other art forms. At a time when accusations of cultural appropriation were rife, The Costume Institute took a risk but it clearly paid off as the show was one of the most-visited of all time from The Costume Institute. Marc Jacobs showed up with a surprise guest – Cher – while Rihanna wore her infamous Guo Pei dress. Others, like Jennifer Lawrence and Dakota Johnson, dressed in less thematic gowns.

The exhibition was a collaboration between The Costume Institute and the Department of Asian Art and included the work of designers Paul Poiret and Yves Saint Laurent, each of whom created fashion that referenced China in their own ways. Juxtaposed with rarely-seen art, moving film and artefacts, they came together to create visual scenery that looked dreamlike and expansive. It was one of the few exhibitions to incorporate so many different types of art, as well as cross the boundaries of art, costume, geography, history, decoration, film and cultural heritage.

71

The exhibition showcased some of the most decadent and ornate fashion inspired by Chinese culture.

# MANUS X MACHINA FASHION IN AN AGE OF TECHNOLOGY, 2016

**One of the more academic examples of thematic exhibitions was the show that took place in 2016.**

It focused on the dichotomy between machine made and handmade clothing. Over 170 ensembles dating from the early twentieth century to the present day traced the early beginnings of haute couture in the nineteenth century to the onset of mass production. One example? A 2014 Karl Lagerfeld for Chanel haute couture wedding gown with a 20-foot train – hand-painted in gold, machine-printed with rhinestones and hand-embroidered with pearls and gemstones. It was the first show fully curated by Andrew Bolton on his own. Many of the celebrities who attended, like Beyoncé and Madonna, wore futuristic, body-skimming gowns. Madonna wore a bondage inspired get-up by Givenchy.

This show was inspired by a personal moment of discovery by Bolton. While studying Yves Saint Laurent's original Mondrian dress up close, which he had always assumed was hand-sewn, he was shocked to find that it was made almost entirely by machine. And thus, the idea was born. Other interesting examples in the show played with the idea of combining machine and man-made, like the aforementioned Chanel wedding dress which included a pattern that was computer-generated, but embroidery done by hand – with 450 hours of workmanship.

72

The regal Chanel haute couture gowns served as one of the biggest contrasts and examples of craft.

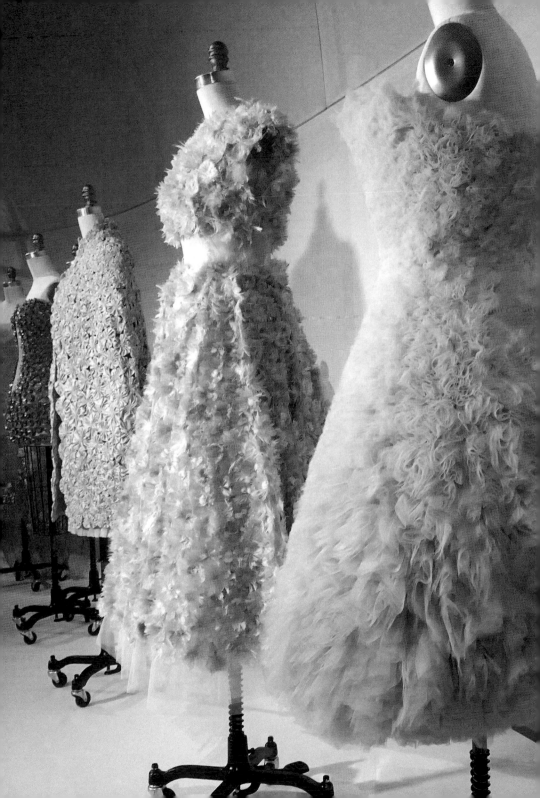

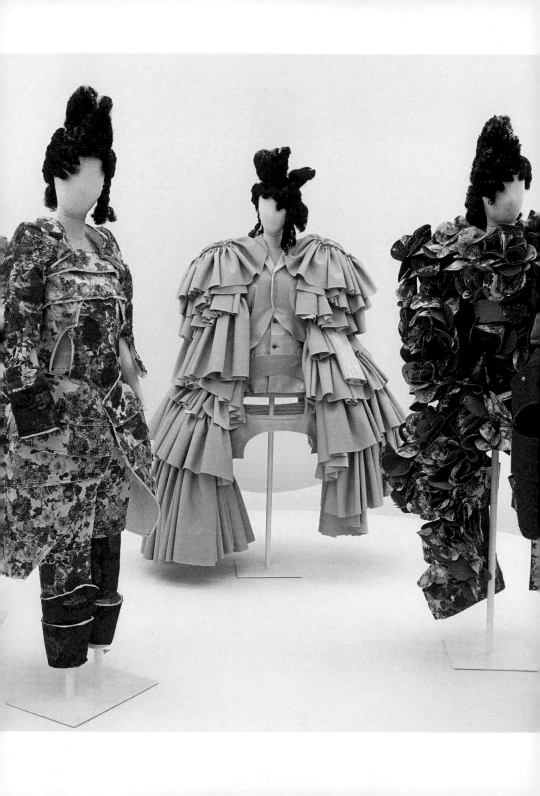

# REI KAWAKUBO/ COMME DES GARÇONS
## ART OF THE IN-BETWEEN, 2017

**In 2017, the Met Gala theme was boundary breaking for a few reasons. It was the first time The Costume Institute chose to focus the annual exhibition solely on the work of one singular female designer as well as on a Japanese designer.**

Organized in one all-white space, the show had a more intimate feel than previous themes, allowing the audience to get a close-up, granular view of one of the world's most intriguing fashion designers. Arranged thematically, it featured 140 examples of Kawakubo's designs for Comme des Garçons, from the early 1980s to current collections, with dramatic headpieces and wigs created and styled by Julien d'Ys, who frequently collaborated on the hair at the brand's runway shows. Only a handful of major celebrities wore Comme des Garçons on the red carpet, including Tracee Ellis Ross, Rihanna, Pharrell Williams and Caroline Kennedy.

75

Opposite: Examples of Rei Kawakubo's designs for Comme des Garçons in the museum exhibition, which ignore all things traditional and take up space.

Overleaf: "I work in three shades of black," Comme des Garçons founder and designer Rei Kawakubo famously said of her often stark black constructed clothing,

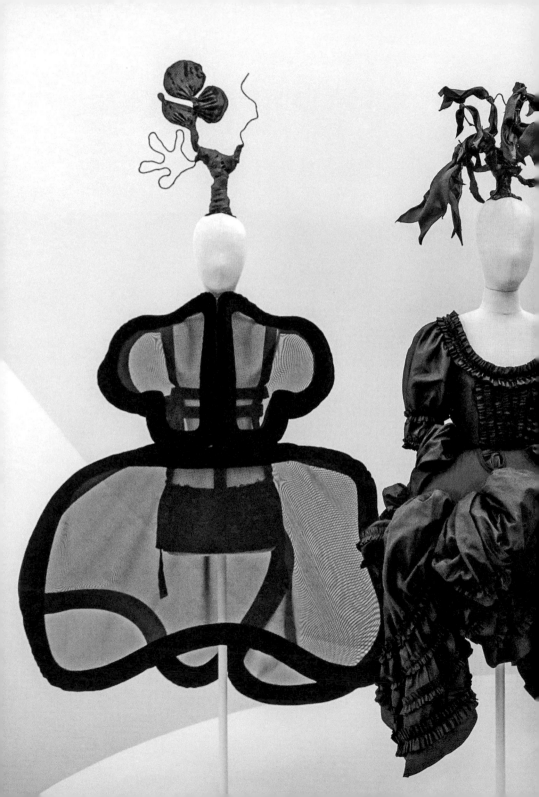

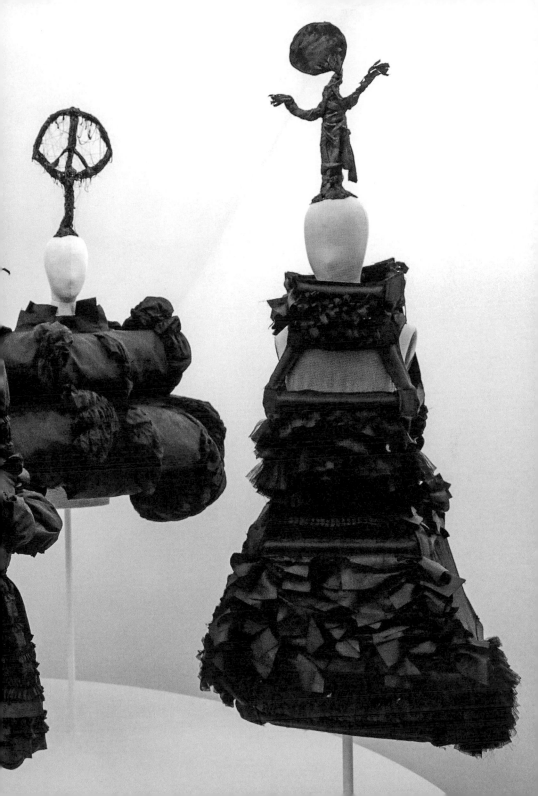

# HEAVENLY BODIES
## FASHION AND THE CATHOLIC IMAGINATION, 2018

**Clearly, the more controversial, the better the exhibition performs.**

In this case, The Costume Institute's deep dive into the fashion depicting the devotional practices and traditions of Catholicism was a huge hit, and the Met's most-visited exhibition of all time. A sort of display of Heaven on Earth, the sartorial feat presented garments which had never been seen outside The Vatican, as well as contemporary designer fashion inspired by ecclesiastical influence. Gala guests played with the ideas of decadence, opulence and all-out ostentatiousness. Rihanna wore a jewel-covered bishop's hat and Katy Perry had angel wings. The visually stunning show spanned The Met Fifth Avenue and The Met Cloisters, making it feel incredibly vast.

"Heavenly Bodies" at the time was the largest exhibition ever offered by the Met's Costume Institute. It featured the work of 55 different designers.

The clothing in the "Heavenly Bodies: Fashion and the Catholic Imagination" exhibition of 2018 mixed the secular with the sartorial in a whirlwind of ecclesiastical examples of fashion.

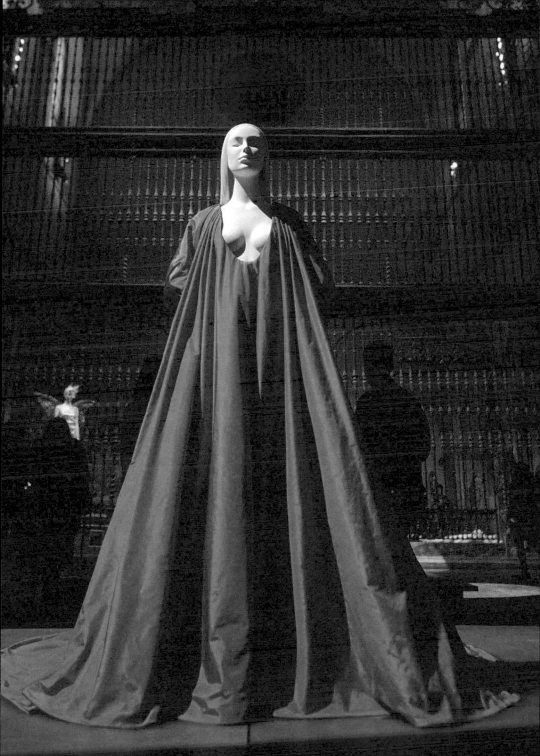

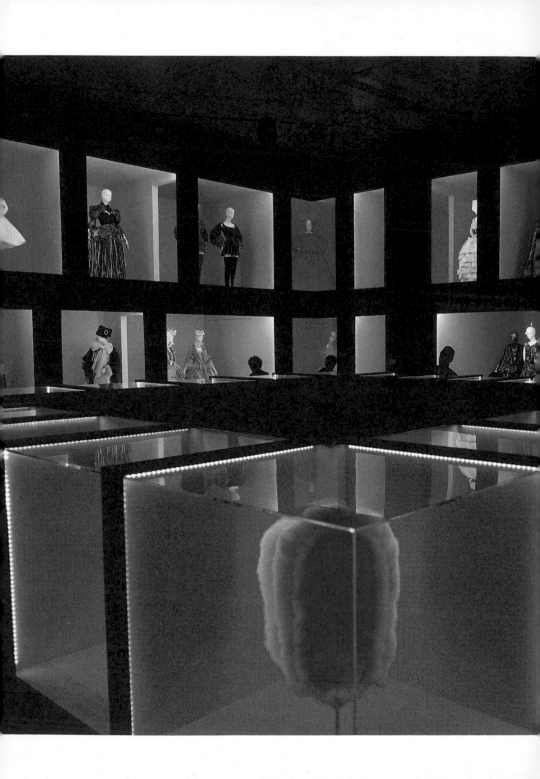

# CAMP NOTES ON FASHION, 2019

**Presented in a mostly pink setting, Susan Sontag's 1964 essay, "Notes on 'Camp", served as the framework for the 2019 show, which many might say was the most fun and daring attempt The Costume Institute made at contextualizing fashion in recent years.**

This was a show that opened a conversation about taste – starting with examples of camp culture's signature gesture known as "the camp pose" and continued by filtering the concept of camp through taste, gender, race and sexuality in fashion. As expected, this year's opening had some of the most iconic red-carpet outfits of all time, from Billy Porter's "Sun God" ensemble by The Blonds to Cardi B in Thom Browne.

81

**"Many things in the world have not been named; and many things, even if they have been named, have never been described. One of these is the sensibility ... that goes by the cult name of 'Camp.'"**

*Susan Sontag*

Bright colours, especially pink, dominated the "Camp: Notes on Fashion" exhibition (2019), with a big emphasis on fashion that spoke volumes about fun.

# KARL LAGERFELD
# A LINE OF BEAUTY,
# 2023

**One hundred and fifty pieces were displayed from one of fashion's most prolific designers of all time in 2023.**

"Karl Lagerfeld: A Line of Beauty" offered up an array of aesthetic themes that Lagerfeld honed in on, from the 1950s to his final collection in 2019. Interestingly, the designer famously hated retrospectives, which made The Costume Institute's choice of theme all the more interesting. It was slightly controversial too, due to Lagerfeld's outspoken statements about different body types, women and the #MeToo movement in the past. For many, it created discourse on the idea of separating the art from the artist. Showcasing his work from Balmain, Patou, Chloé, Fendi, Chanel and his eponymous label, Karl Lagerfeld, many of the celebrities dressed in black and white in tribute to the designer on the red carpet.

82

**"I've always known that I was made to live this way, that I would be this sort of legend."**

*Karl Lagerfeld*

Karl Lagerfeld's exhibition explored his body of work and showed many examples of black and white fashion.

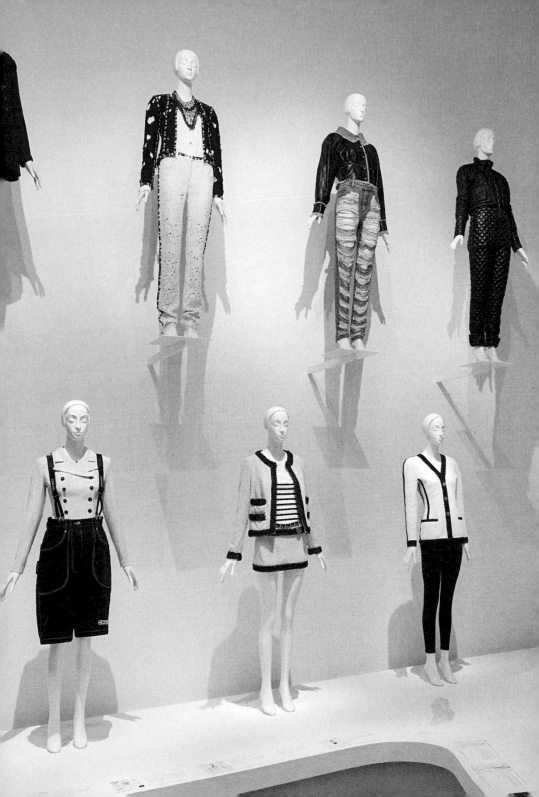

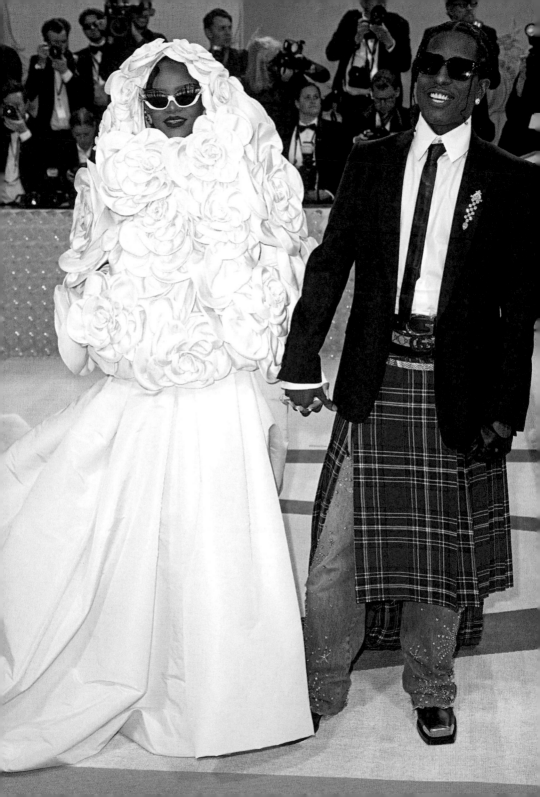

# THE STYLE
# ICONS ...

# SETTING THE STAGE

**What makes a celebrity an influential regular at the Met Gala? For those who attend more than once, it's a lot more than dressing to fit a narrow theme. It's about dedicating oneself to the art of taking very particular risks and playing along with the very strict and narrow rules set forward by the Met Gala and *Vogue*'s Anna Wintour.**

Having an incredibly memorable look one year doesn't guarantee an instant icon status in the canon of Met Gala attendees. To get to that level of fashion fame requires a dedication to storytelling, theme and narrative.

Many of the celebrities who have become well-known not just for attending the Met Gala – but for dressing for it – have prolific stylists to whom much credit is owed. Often, everything that you see on the red carpet is owed to a huge team consisting of designers, stylists, hair, make-up and nail teams – even tailors. Take, for instance, Zendaya and Law Roach – the mastermind stylist behind most of her iconic looks – who walked the red carpet as her fairy godmother with a wand when she wore a light-up gown in 2019. "Sometimes Zendaya calls me her fairy godbrother or godmother depending on how I'm acting that day," Roach told *Who What Wear*. "The story was that she was leaving Disney, and this was before *Euphoria* premiered. That was to pay homage to her career as a Disney princess." Reportedly, Zendaya even lost one of her glass slippers at the top of the infamous Met Gala stairs, making for an even more dramatic retelling of *Cinderella* to the ascension of Zendaya, a household icon. That's true storytelling through the art of clothing.

86

Previous: Rihanna and A$AP Rocky attending the 2023 Met Gala in their version of outfits honouring the legacy of Karl Lagerfeld.

Below: Zendaya and her stylist Law Roach, creating a transformational Disney Princess moment on the 2019 Met Gala red carpet.

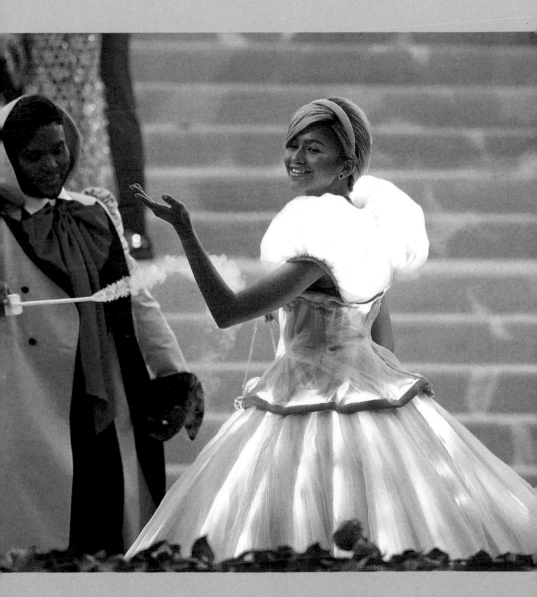

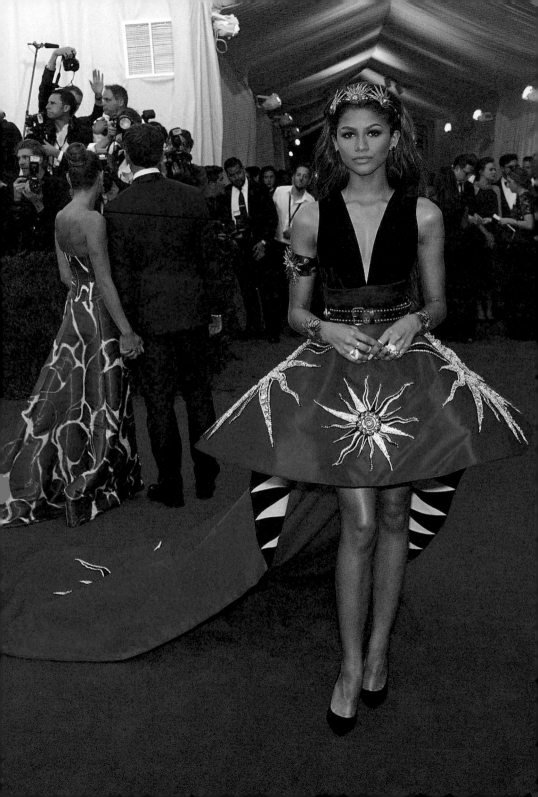

Celebrities, it seems, are likely to be more open to trying new things for the Met Gala than a traditional red-carpet event – especially when it comes to hair and make-up to support the look. It's about a total 360 transformation of character. "The Met Ball is such a high," Emma Stone's hair stylist and make-up artist, Mara Roszak, told the *New York Times*. "We really get to showcase our creativity in a major way."

"It allows for more creativity," the celebrity stylist Petra Flannery, whose clients include Emma Stone and Zoe Saldana, agrees. "People let their guards down a little bit . . . You can get away with being a little more avant-garde, a little more creative, a little more crazy."

Anna Wintour approves every single guest who attends, including those invited by designers or brands who buy tables. And she also approves every detail, including the seating charts, and has been known to

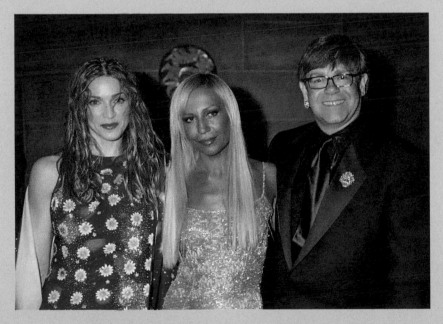

Opposite: Zendaya, a fashion favourite, at the Met Gala in 2015.

Above: Madonna, Donatella Versace and Elton John gather at the Met Gala.

ban certain celebrities, if they speak poorly of her, which reportedly happened to the actor Billy Porter in 2023. Typically, the event only includes a few hundred guests. "We do want the experience to feel intimate for our guests, so in the past few years, we've really scaled back and dropped numbers by almost 200 or 300 people," Sylvana Ward Durrett, the former director of special projects, responsible for organizing the Met Gala for eight years, told *Fast Company*.

The style icons inside are not allowed to take photos on their phones (though there are always a few stealthy rule-breakers) and they're also discouraged from using their phones at the table during the dinner. "Anna is sort of an old-school traditionalist. She likes a dinner party where people are actually speaking to each other," Durrett explained in *The First Monday in May*, a documentary directed by Andrew Rossi, focusing on the 2015 Gala. Other rules include the obvious no-smoking rule, no minors under the age of 18 (unless accompanied by a parent: Jaden and Willow Smith attended in 2016 aged 17 and 15, Elle Fanning attended at 13, while Hailee Steinfeld attended at 14), and typically, no spouses are seated together. "The whole point of these things is to meet new people, and to be interested in what others are doing. What's the point if you come here to hang out with your husband?" declared Durrett.

Some of the most popular celebrities at the event may not even be considered the best dressed but if they can create discourse with what they're wearing and drum up interest consistently, that's key. After all, that's the point of the Met Gala's efforts: to put forth ideas that make people think.

Katy Perry at the Met Gala wearing the infamous cheeseburger outfit created by Jeremy Scott for Moschino in 2019.

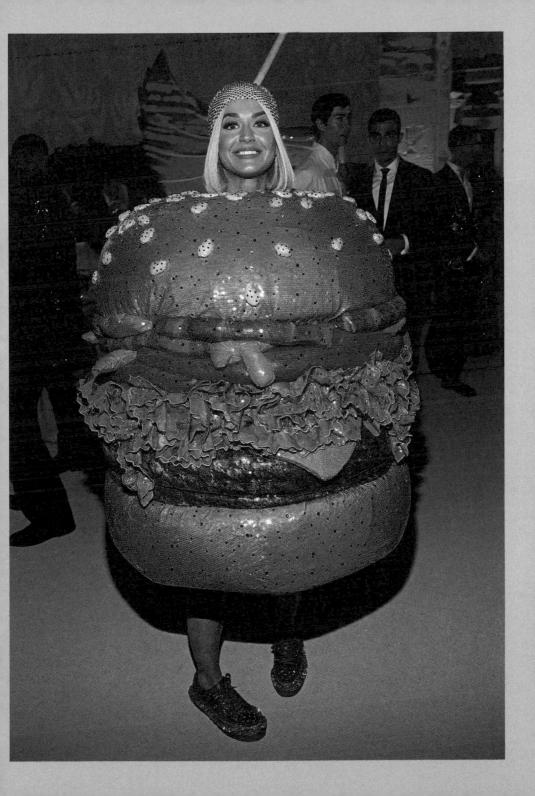

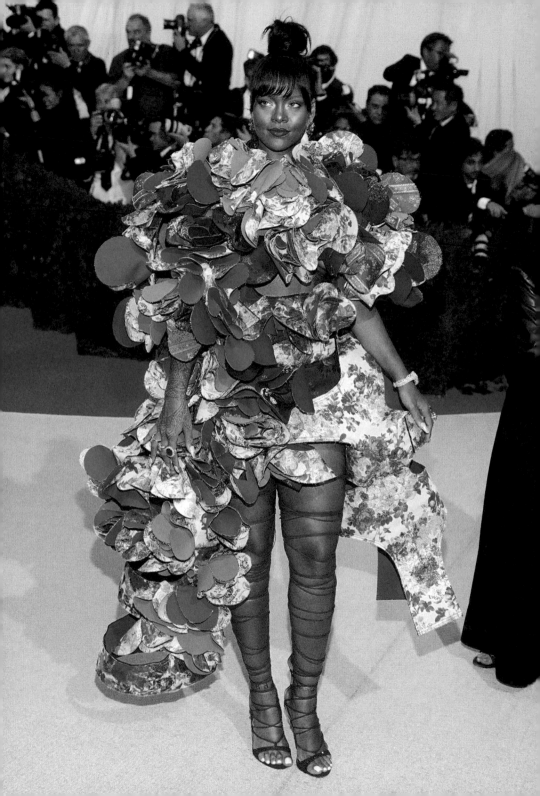

# RIHANNA

**Global superstar Rihanna first attended the Met Gala in 2007, and though she has always been well-dressed, It took a couple of seasons before she became the de facto queen of the museum's well-worn, red-carpeted stairs.**

She started out safe – donning a white Georges Chakra gown covered in a sea of glimmering crystals near the neckline for her first Met Gala. As for accessories, she finished off the look with black mesh gloves and a single red rose to tie in with the "Poiret: King of Fashion" theme. As time went on, she took more risks with her fashion choices.

In 2009, she wore a structured Dolce & Gabbana suit with a bow tie and sky-high black stilettos for the "The Model as Muse" Met Gala. Most people know her for her 2015 look worn to the "China Through the Looking Glass" opening. She wore an extravagant yellow gown by Chinese designer Guo Pei. The designer herself said "only women who have the confidence of a queen could wear it." Rihanna was one of the few celebrities to wear Comme des Garçons to the "Rei Kawakubo/Comme des Garçons: Art of the In-Between" Gala in spring 2017. In 2023, with the crowd eagerly waiting, she was fashionably late to walk the red carpet in a Valentino hooded cape set over a white ballgown. She was visibly pregnant which was a boundary breaker for red carpet style in and of itself.

93

Rihanna wore a Comme des Garçons look to the 2017 Met Gala, straight off the Fall 2016 runway. Inspired by eighteenth-century "punks" – it pulled apart like a giant flower.

# LADY GAGA

**Singer-songwriter Lady Gaga may have only started going to the Met Gala in 2015, but she's made an incredible impact in terms of pushing the boundaries of personal style and performance far beyond the norms.**

Her first ever look was a sheer black Alexander Wang for Balenciaga gown with a dramatically plunging V-neckline. Complete with an oversized white netted coat with black feathers and a regal black diamond tiara, not only was it influential for red carpet style, it's also one of the few impactful moments from the period when Alexander Wang designed for Balenciaga. For the "Manus x Machina: Fashion in an Age of Technology" Gala (2016), she wore a silver leotard by Versace that included no pants – a play on her signature look during that time. Susan Sontag's 1964 essay "Camp: Notes on Fashion" provided the framework for the 2019 Gala, in which the singer staged a performance-style red-carpet extravaganza complete with four different outfits.

94

## "My fashion is part of who I am, and though I was not born with these clothes on, I was born this way."

*Lady Gaga*

Lady Gaga is the Queen of Experimentation and takes her character to the next level for all her Met Gala appearances, crafting new personas through hair and make-up.

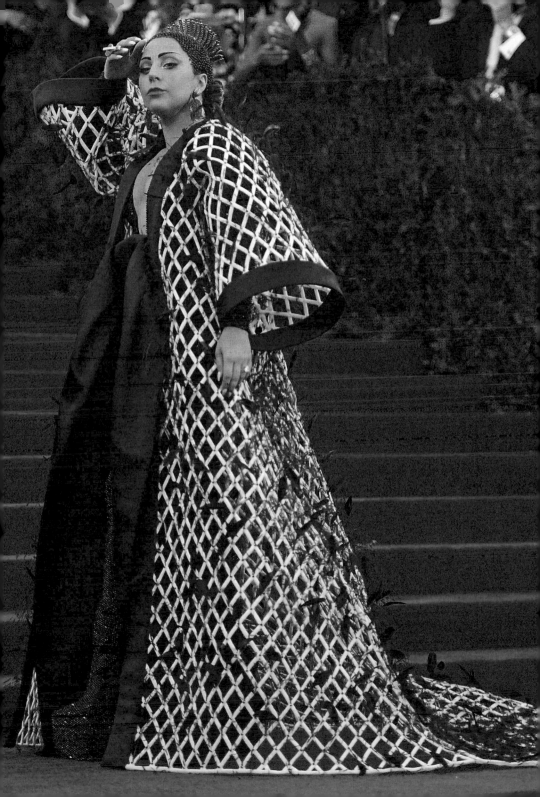

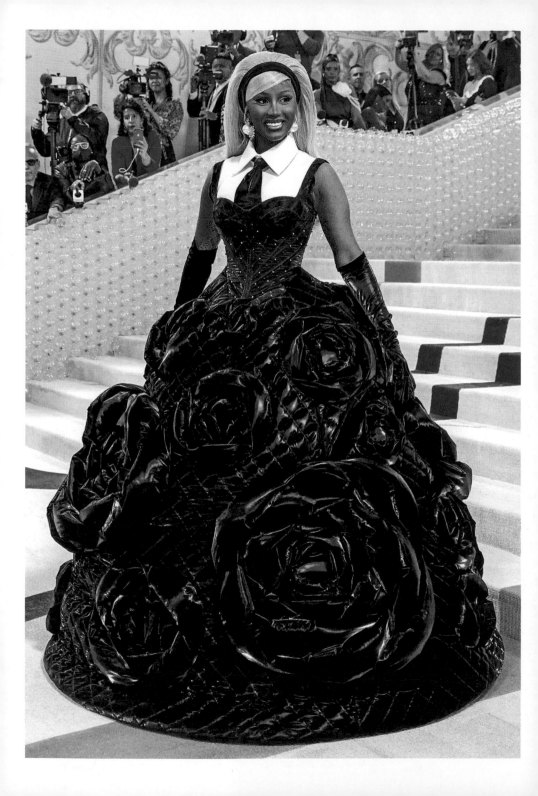

# CARDI B

**A relative newcomer to the Met Gala world, American rapper Cardi B is setting a brand-new standard in the art of dressing for the Met red carpet.**

She attended her first Met Gala in 2018, visibly pregnant, wearing a regal pearl and gemstone embellished gown designed by Jeremy Scott for Moschino but made the biggest impact in 2023, at the "Karl Lagerfeld: A Line of Beauty" event. Consider this: the fact that she didn't commit to just one major outfit, but wore four different looks. What also makes her stand out in a sea of celebrities, socialites and fashion industry power players? The fact that she gives emerging designers a platform rather than just sticking to familiar household names.

She started out the night in a brilliant pink tulle confection by the new designer on the scene, Miss Sohee, then later switched to a gorgeous black flower-covered gown by the rising name to know, Chenpeng Studio. Later on, she changed into a pink tweed gown by Richard Quinn, followed by a custom newspaper print dress by Sergio Castaño Peña. It's not often you see newer designer names on the Met Gala red carpet since most of the designers who can afford to attend and bring a celebrity guest are usually big name brands.

97

Rapper Cardi B in a black flower-covered gown by Chenpeng Studio, in 2023.

# MADONNA

**Name a theme and Madonna will deliver, as the singer has proved consistently over the years. Madonna has a knack for following themes but somehow keeping her own sense of personal style intact.**

She also comes to the Met Gala with a unique sort of aesthetic. As one of the greatest performers of all time, she has walked the red carpet and performed for guests during the Gala. In 2018, she wore a monastic robe and delivered a surprise appearance, belting out "Like a Prayer". Is there any other star who could have done "Heavenly Bodies: Fashion and the Catholic Imagination" justice? One of her best Met Gala moments was the Gianni Versace themed gala. For this, she wore a Versace Spring/Summer 1998 Ready-to-Wear crystal beaded cut-out silk evening dress and a pair of silver Dolce & Gabbana sandals from the Spring/Summer 1998 collection.

98

**"Religion and spirituality is an important part of my work, for my entire career. And fashion also. Combining the two is the perfect marriage."**

*Madonna*

Madonna, singer and muse, consistently creates new aesthetics through her artful dressing at the Met Gala.

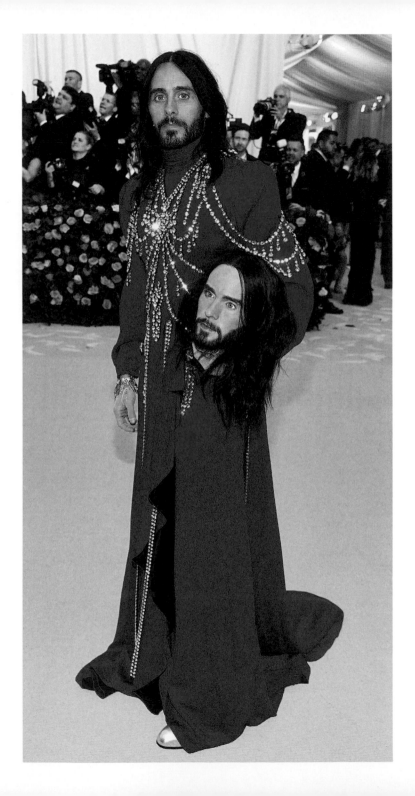

# JARED LETO

**Ever the rule-breaker, Hollywood actor and musician Jared Leto has crossed boundaries on the Met Gala red carpet that no one else has dared to cross.**

Because of this, he's become a source of entertainment and someone that people eagerly await on the red carpet. Take, for instance, in 2023, when he dressed as Karl Lagerfeld's cat, Choupette – the beloved pet the legendary designer reportedly left a £1.3m ($1.6m) inheritance. The lifelike costume was designed by Joshua Balster, project manager of production studio SCPS. No one knew who Leto was as he stepped out onto the red carpet. That is, until he removed the hyperrealist head.

The year prior, it was announced that the actor was partnering with Lagerfeld's fashion house to create a feature film about the late German fashion icon and playing the role of the designer in the biopic, too. "Karl Lagerfeld was famous not just for being Karl Lagerfeld, but he had a cat named Choupette," said Leto. "I just thought if Karl could see that costume, he would just be laughing and smiling and he would love it. It's fun to go to a big event like that with something kind of silly." In 2019, he carried a replica of his head on the Met Gala red carpet, inspired by a Gucci runway show in which models carried fake versions of their own heads. The actor often chooses to wear things that make people question the ideas of what costume is and what is art – maybe, even what fashion is.

101

Actor and musician Jared Leto twinning with his fake head on the Met Gala red carpet.

# AMBER VALLETTA

**As one of the ultimate fashion industry muses, American model and actress Amber Valletta consistently delivers by doing something different each time she attends the Met Gala.**

Her favourite theme is obvious: "Model as Muse". She told *Fashionista*: "To come in and be part of the exhibit, to actually see my pictures and my influence in fashion was being commemorated within the museum was pretty awesome; you can't beat that. I was like, 'Wow, I'm part of this.'" But it was her stunning Maggie Norris hand-painted couture corset and John Galliano Autumn/Winter 2004 skirt, complete with a Marie Antoinette-style updo worn to the "Dangerous Liaisons: Fashion and Furniture in the Eighteenth Century" Gala that was her most extravagant moment. She brings the point of view of the supermodel to the red carpet – always opting for dramatic silhouettes that frame the body in intriguing ways.

102

> **"Anna [Wintour] asked me to come to the Met and she said, 'come up to the offices and we'll dress you.' The part that's really important about this whole thing is that she said, 'I really want you to go for it.'"**

*Amber Valletta*

Sometimes some of the best Met Gala red-carpet looks hinge on costume.

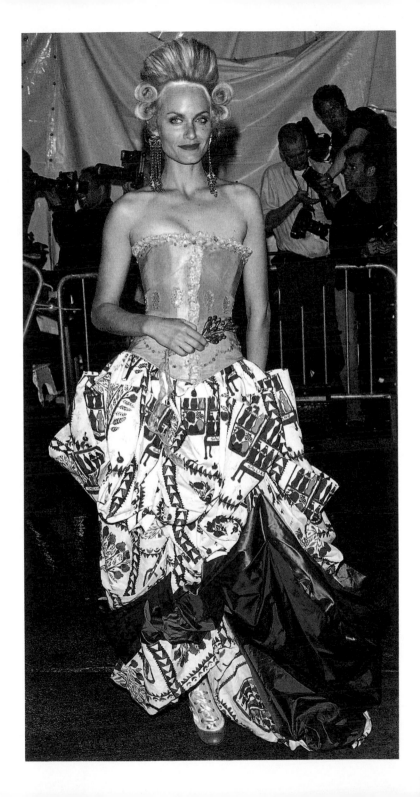

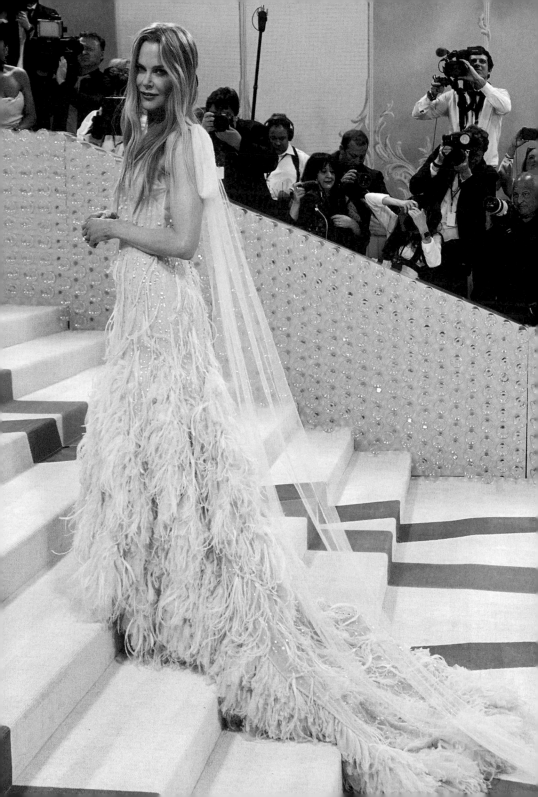

# NICOLE KIDMAN

**She's only made an appearance a handful of times, but each time Hollywood's top Australian icon Nicole Kidman attends the Met Gala, she shows us her precision for dressing, nailing the theme to a tee with a flawless execution.**

She's Nicole Kidman, after all, so it's to be expected that she'd dress like a movie star. She caused debate and discourse online when she showed up to the 2023 Met Gala. Climbing up the famous red stairs in all her glory, she sported the very same cream-coloured ethereal creation that she wore in a commercial in 2004 when she was the face of Chanel No.5. Kidman declared the look was all about being "able to honour Karl and show I suppose the way these couture gowns last, and the exquisiteness; if you take care of them and love them they are timeless. To be able to wear the same thing 20 years later and it still holds, because there's whimsy to it."

In 2016, she wore an equally stunning Alexander McQueen gown covered in celestial silver trimmings. Then, in 2003, she co-hosted alongside Tom Ford, wearing one of his nude, shimmering sheer gowns. In 2005, she co-hosted once more, this time alongside Karl Lagerfeld, wearing a haute couture floor-length strapless navy-blue gown by Chanel.

105

In 2023, Hollywood's Nicole Kidman revisited the same cream-coloured ethereal creation that she wore in a commercial in 2004 when she was the face of Chanel No.5.

# SARAH JESSICA PARKER

**If you take away one thing from Sarah Jessica Parker's Met Gala thinking, it's that above all else, she takes the themes very seriously.**

The award-winning actress and fashion icon has been attending the Met Gala since 1995, but most people are unaware that for her first Met Gala, she bought her long black slip dress from a thrift store and did her own make-up. One of her most memorable looks was worn for the "PUNK: From Chaos to Couture" gala (2013), in which she donned a Giles Deacon dress with gilded embellishments and a tartan lining. She topped the look off with a Philip Treacy headpiece that resembled a golden hairpiece topped with a black mohawk. The accessory was so tall, Parker reportedly had to sit on the floor of her car on the way to the event.

She intentionally puts a lot of research into her Met Gala looks. "Whenever I go to the Met, I don't understand how everyone else didn't spend 7 to 10 months working on it," she told *Vogue*. "The assignment is the theme, and you should interpret it. It should be labour-intensive and challenging."

106

Actress and film producer Sarah Jessica Parker is the ultimate theme-follower. Here, she wore a headpiece so large that she reportedly had to sit on the floor of her car on the way to the event.

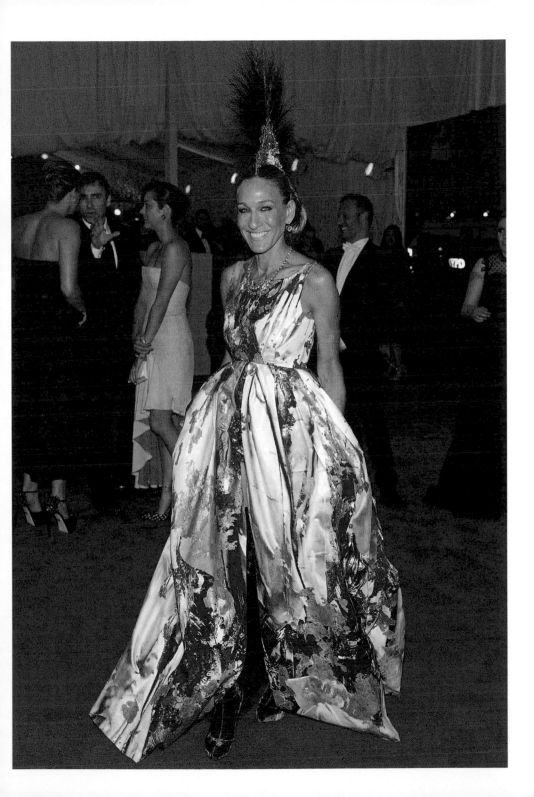

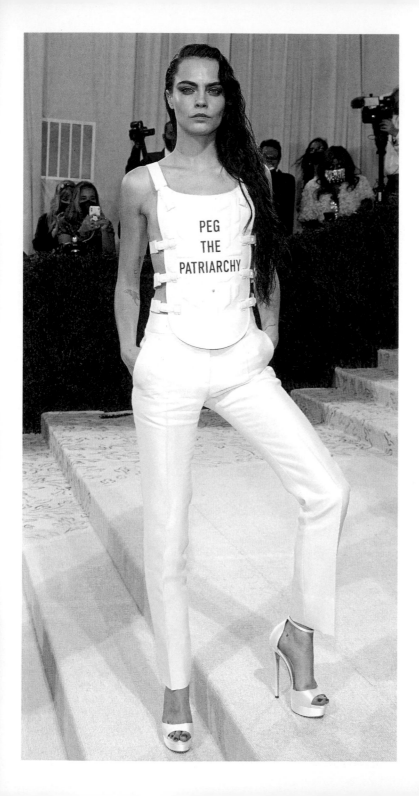

# CARA DELEVINGNE

**In 2023, *Vogue* described Cara Delevingne as one of the Met Gala's biggest risk takers, and it's true. Somehow, since 2011, the famous model from the Tumblr era of fashion has propelled herself into being one of the most interesting fashion guests at the Gala.**

In 2021, she shocked and provoked when she wore a white top by Dior resembling a bulletproof vest and printed with the words, "Peg The Patriarchy", which was hotly discussed. The model said, "It's about women empowerment, gender equality – it's a bit 'stick it to the man'." In 2022, she wore a red tailored suit from Dior Haute Couture and took off the jacket mid-red carpet to reveal her naked chest covered in gold body paint and chains – her eyes rimmed in rhinestones. She was later praised for embracing her psoriasis – red flaky patches left unpainted on her elbows.

Delevingne constantly explores the true fantasy of the Met Gala, bringing experimental hair and make-up along the way. Her 2019 headpiece by the artist Machine Dazzle featured googly eyes, a fried egg, fake dentures and bananas, showing that she's willing to go to great lengths to match the theme.

109

Model and actress Cara Delevingne wearing one of her most memorable Dior looks to the Met Gala, 2021.

# ZENDAYA

**In recent years, we've seen the accession of Zendaya as a total style icon and many of her Met Gala looks helped give her that title.**

Among the most iconic was the look she wore to "Heavenly Bodies: Fashion and the Catholic Imagination" (2018). Resembling a modern Joan of Arc, she donned a silver chainmail-inspired Atelier Versace dress. Almost as famous as Zendaya is her stylist, Law Roach, the man behind the outfits. In 2019, he dressed as her fairy godmother as her blue Tommy Hilfiger gown with a tulle overlay, corseted bodice and exaggerated sleeves appeared to light up – like a real Cinderella come to life. Her 2017 Dolce & Gabbana gown sprawled across the stairs, creating a moment that was just as cinematic. With a yellow and burnt orange colour palette, plus large, printed parrots, the off-the-shoulder gown was so spectacular, Rihanna herself posted a tribute on Instagram, with the caption, "black goddess."

"It has to be literal enough so that people get it," Zendaya's stylist, Law Roach, told *Vogue* of her light-up gown. "When you see Cinderella, you know right away it's her; the baby blue dress and the hair and the French twist – it all works together. We hunted down the people who created the technology used in the Chalayan show and who did all the mechanics to create those garments, then brought them to Tommy to collaborate with us on this."

110

Actress-singer Zendaya's silver chainmail-meets-Joan-of-Arc dress by Atelier Versace wowed the crowd.

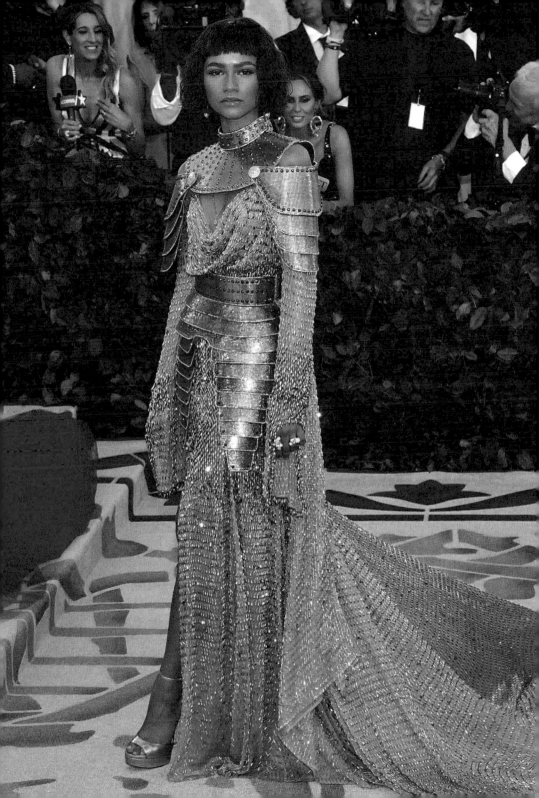

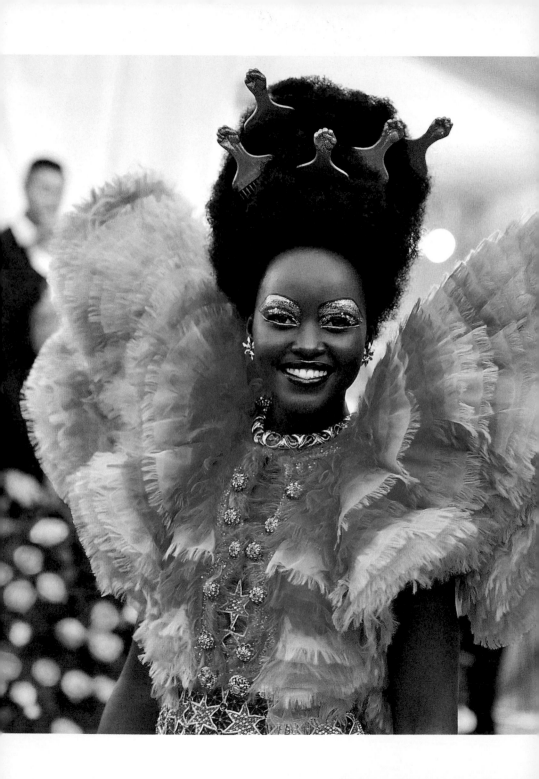

# LUPITA NYONG'O

**Not only does she redefine fashion with her glorious choices, Academy Award-winning actress Lupita Nyong'o also opts for bold beauty looks that are a forever source of inspiration.**

Take, for example, when she arrived on the red carpet in 2016 with a sky-high stacked spherical hairstyle paired with a green mermaid-like sequin slip dress adorned with 6,000 pearls by Calvin Klein. In 2019, she opted for a fluorescent rainbow Versace gown paired with an Afro, topped off with five golden picks inspired by Lauren Kelley's self-portrait "Pickin'" (2007), which showcases the artist wearing a crown of hair picks. The style was created by hairstylist Vernon François and stemmed from her role in the upcoming film, *Queen of Katwe*. In 2021, she continued her tradition of mixing creative flair and hair with a denim Versace dress and folded spirals of hair inspired by the conceptual artist, Lorna Simpson.

113

**"Our goal was to demonstrate the power, malleability and luxuriousness of natural hair texture,"**

*hairstylist Vernon François told* **Vogue**

Hairstylist Vernon François has been a frequent and celebrated collaborator of the star – often creating incredible works of art to rival the fashion she wears on the red carpet.

# BLAKE LIVELY

**It's no wonder Blake Lively has become a regular at the Met Gala since 2008. After all, she goes for total embodiment of glam.**

The American actress has become an icon that represents the epitome of glamour as well as someone who manages to take more traditional formal gowns and add a dramatic flair that is both artful and conceptual. She often chooses dresses with extremely long trains. In 2014, she served as the ultimate picture of Old Hollywood wearing Gucci – and she matched her husband and fellow actor, Ryan Reynolds, who wore a tailored tuxedo in stark juxtaposition to her blush-hued, figure-skimming dress with decadent draping. And take, for example, the year 2018 when she wore an ornate Versace look in ruby and gold. The bodice reportedly took over 600 hours to bead, and the iconic train was so long, she had to take a party bus to the venue.

In 2022, for the Gala for the opening of "In America: An Anthology of Fashion", she wore a patinated dress in homage to New York City and so many of its classic, iconic buildings. There was detailing from the Empire State Building, draping representing the Statue of Liberty, constellations from Grand Central Station, all topped off with a seven-spiked crown inspired by the Statue of Liberty, also paying tribute to the idea of seven seas and the seven continents, which represents inclusivity, welcomeness and freedom.

In 2022 Blake Lively wore a patinated dress in homage to New York City and so many of its iconic buildings, for the opening of "In America: An Anthology of Fashion".

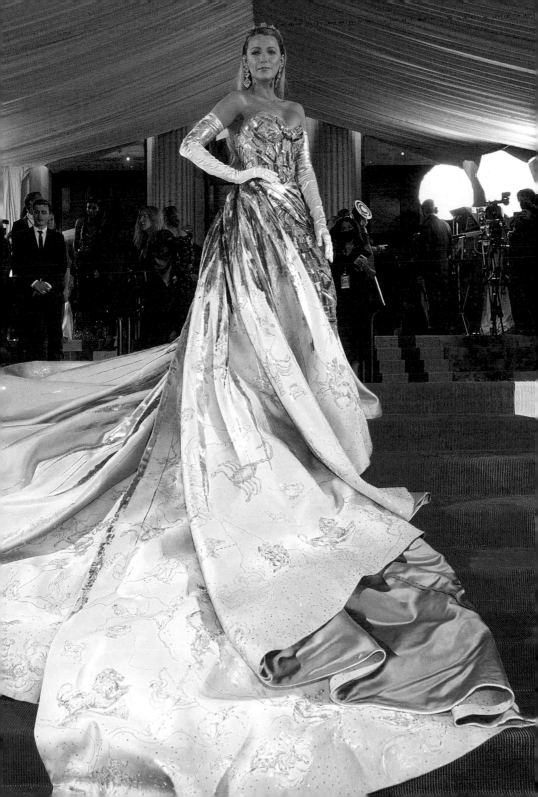

# NAOMI CAMPBELL

**There's a reason why Naomi Campbell is one of the fashion world's top supermodels. Her walks and personality made her legendary, and likewise, her red-carpet choices are equally iconic.**

Campbell began attending the Met Gala in the nineties. Her first ever event was in 1990, for the "Théâtre de la Mode: Fashion Dolls: The Survival of Haute Couture" exhibition. She wore a colourful Gianni Versace minidress and served as one of the designer's guests to the event. Her roommate at the time, fellow supermodel Christy Turlington, helped her score the invite. "The '90s was a time when you wore everything," she told *Vogue*. "You dressed up in the '90s. We would all go to dinner outside of work, Christy, Linda and I – we would all dress up to enjoy your clothes, enjoy your accessories, enjoy your hair."

Campbell took a risk in 2001 for the theme "Jacqueline Kennedy: The White House Years" with a black bodysuit that read "Like a Virgin" with black lace tights and crystal crucifix necklaces by Dolce & Gabbana. Then in 2003, "Goddess: The Classical Mode", her brick-red fringe gown turned heads when she was photographed alongside Victoria Beckham and Sean Combs. She accessorized with a ruby coloured choker and cross necklace.

Campbell has often worn the late Alexander McQueen's visionary shape-shifting work. In 2006, her ice-green kimono proved another showstopper and she was photographed with her friend and former *Vogue* editor-at-large, the late André Leon Talley.

117

Naomi Campbell always opts for a dramatic silhouette each time she walks the red carpet.

# JENNIFER LOPEZ

**Since 1999, J-Lo has stunned on the red carpet with ultra-glamorous looks that are equally risqué and dramatic.**

There's a reason why she's credited with the creation of Google Images – in her green, plunging Versace "Jungle" gown that scooped down to her navel for the 1999 Grammy Awards. The actress often opts for gowns that display skin in striking ways, such as when she chose a custom Ralph Lauren gown in 2023, with a plunging top that revealed a triangle of her upper midriff. Her beaded, sequinned flapper-inspired Versace dress that she wore in 2019 ("Camp: Notes on Fashion"), complete with matching headpiece, showed that she's also not afraid to get experimental.

Somehow, she manages to make even the most revealing pieces – like her sheer panelled Versace gown with embroidered dragons – look intriguing. "I like things that I know I can bring to life, things that stand out," she said on the Met Gala's stairs in 2023. "I don't like ordinary things. I like things that are a wow. I'm a performer. I'm an entertainer, so I love sparkle and glamour."

Speaking of her upbringing in New York she said: "Growing up there in the '80s gave me my first fashion influences. As a girl I didn't have a lot of clothes, but I would cut up my sweatshirts and jeans and make miniskirts out of them, and I'd try to be like my idols – Madonna, Cyndi Lauper."

J-Lo loves a naked dress – and more often than not, you'll see her on the red carpet wearing one.

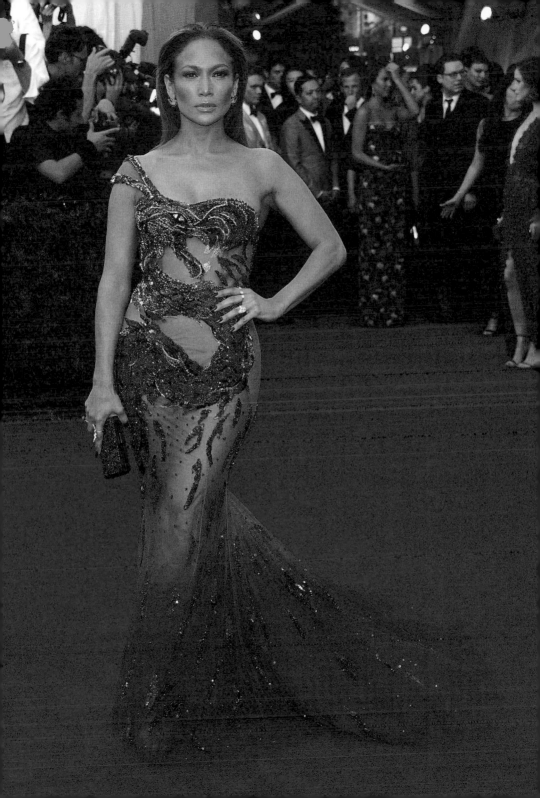

# ANNE HATHAWAY

**The American actress has become an unexpected fan favourite in fashion circles for her personal style.**

Her sleek and minimalistic Valentino red gown in 2014 ("Charles James: Beyond Fashion") showed that she has the ability to dress with an exquisite minimalistic silhouette. For "China: Through the Looking Glass" (2015), she donned a bold gold Ralph Lauren gown featuring a hood – which gave off a mix of futuristic and medieval, with a bit of Grace Jones thrown in. By 2023, jaws dropped as she was being dressed by Versace and opted for a ravishing tweed bodycon dress covered in oversized safety pins (a nod to the Versace archives as well as Karl Lagerfeld's work at Chanel) and glistening pearls. A matching jacket took over 400 hours to make. "It was meant to be a marriage between Versace and Chanel," Hathaway said on the red carpet.

121

**"I feel like designers are having a lot of fun. I feel like people are enjoying it. Maybe it was always the case ... But just the ability to enjoy it feels like it's more available to me now than it ever was before."**

*Anne Hathaway*

Anne Hathaway always surprises everyone on the Met Gala red carpet, like when she wore a bold gold Ralph Lauren gown featuring a hood.

# ANDRÉ LEON TALLEY

**For years, the late great André Leon Talley stood as a beacon of light on the Met Gala red carpet as he interviewed all the A-list celebrities on behalf of *Vogue*.**

But he wasn't just a face – he was a fashion icon in his own right, wearing custom pieces from his favourite designers and friends. He often wore grand kaftans, which lent themselves to unapologetically dramatic entrances. At the 2004 Met Gala ("Dangerous Liaisons") he donned a floor-length, cape-style trench coat by Yves Saint Laurent. In 2011, he wore one of his famous kaftans which billowed across the stairs, in a gorgeous cornflower blue shade. But the 1999 photo of him, wearing a golden brocade jacket, alongside colleague Anna Wintour in a fur, will forever remain one of the most celebrated portraits.

In 2019, for the "Camp: Notes on Fashion" exhibition, a little controversy was added to the mix as he was reportedly replaced, without notice, by YouTube personality and actress Liza Koshy, as the official *Vogue* red-carpet interviewer. After years of iconic, emotional, funny and entertaining interviews, many were shocked. "The Met Ball to me was a moment in time when it meant something," he told fellow journalist Amy Odell. "And Anna Wintour recreated the Met Ball and made it outstanding with the millions of dollars she raised every year. Except the 'Notes on Camp' – the exhibit called 'Notes on Camp'? I think it went off the rails."

With his big personality and penchant for equally big silhouettes, former *Vogue* editor-at-large André Leon Talley (seen here with Anna Wintour) was a Met Gala icon for the ages.

# MARY-KATE &
# ASHLEY OLSEN

**These twin sisters have serious style and can carry off high fashion looks like no one else. Take, for instance, their knack for styling oversized outfits with overzealous amounts of accessories.**

They have also dabbled in wearing vintage, as they did when they attended their first Met Gala, "The House of Chanel", at just 18 years old. In 2023, it's common for celebrities to wear vintage and archive looks from various fashion houses but the Olsens set a new kind of standard, like in 2009, when Mary-Kate wore a vintage Christian Dior haute couture caped dress for the "Model as Muse" Gala.

After the duo founded their high luxury, minimal brand, The Row, in 2006 they began wearing their own designs. Think: black silky gowns – but they always seem to go back to a mix of eclectic vintage, so distinct and uniquely them. They did this in 2015, 2016, 2017, also returning to designer archives for vintage pieces in years to come. In 2019, they arrived in vintage Chanel matching black leather dresses. The duo are never one to speak on the inspiration or process behind their Met Gala looks, making them even more fascinating.

125

The Olsen twins, Mary-Kate and Ashley, have unexpectedly become some of the Met Gala's most eccentric dressers by way of incorporating vintage in their red-carpet looks.

# THE DESIGNERS ...

# A MATCH MADE IN HEAVEN

**Designers are sacred to the Met Gala. Without them, the visionary, boundary-breaking moments you've come to expect from your favourite fashion icons simply wouldn't exist. At the Met Gala, it's all about the muse.**

Typically, the designers or fashion brands who buy a table at the event then invite a handful of celebrities, models or high-profile guests who best align with their aesthetic, style or values. *Vogue*'s Anna Wintour also often invites up-and-coming designers or creatives, who may not be able to pay for their own tickets, and places them around the different tables during dinner.

If a designer invites a celebrity guest, they always dress them. That's just how the rules go. "If celebrities are invited to the gala by a brand, it is an unspoken rule that they have to wear clothes from that brand," wrote Vanessa Friedman for the *New York Times* in 2018. "This encourages said brands to get the best stars, because they can act as something of an advertisement for a house."

The pieces worn by A-list celebrities at the Met Gala – especially if they're going as the guest of a designer – are typically 100 per cent custom, made just for the event, showcasing the design house's top skills for the special occasion. That means that weeks, sometimes months, go into planning and designing the look. Many

128

Previous: Donatella Versace – a designer favourite at the Met Gala – with Rita Ora.

Opposite: Eccentrically dressed designer John Galliano and Charlize Theron attend the "Anglomania" themed Met Gala in 2006.

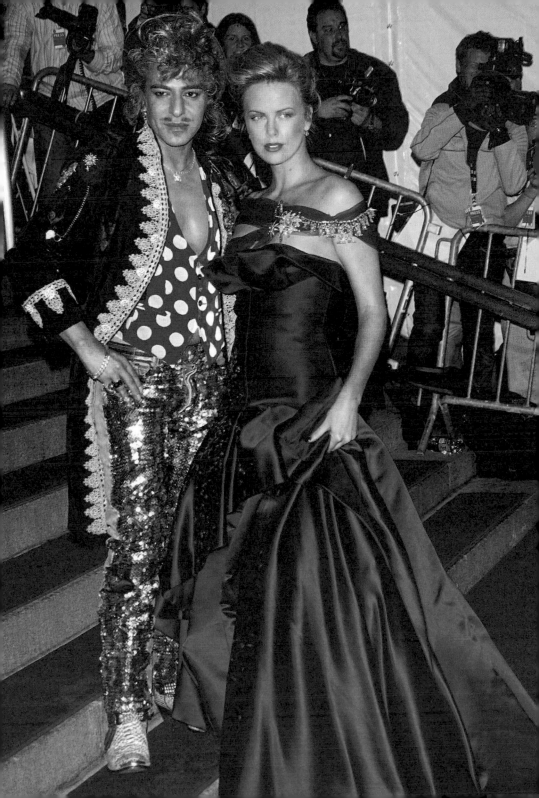

times, the red carpet looks showcased are couture – with handmade details. Like Rihanna's icy floral cape and dress that she wore to 2023's "Karl Lagerfeld: A Line of Beauty" gala. For this, she chose a custom Valentino Haute Couture silk faille dress featuring a cape covered in 30 giant camellia appliqués made of 500 petals and a billowing train. Each flower on the cape took nearly 30 hours to create. Even though designers control what the celebrities wear, it's often a collaborative process, involving personal input and multiple fittings. And then there's also the fact that Anna Wintour approves many of the looks that go down the red carpet. It's estimated that she approves about 80 per cent of what's worn by guests at the Gala, according to journalist Amy Odell's book *Anna*.

Especially when the theme of the exhibition is based on a solo designer, the idea of designer muses has so much impact – including who walks the red carpet and who shows up to the Gala. During 2023's "Karl Lagerfeld: A Line of Beauty", several of the late designer's muses showed up in support, including Devon Aoki, Kristen

Paris Hilton, Marc Jacobs, Kendall Jenner, Anitta and Kim Petras at the 2023 Met Gala.

Stewart, Kate Moss and Alexa Chung. "To sit at the desk with Karl Lagerfeld as he sketched was the most incredible thing," Moss told the *New York Times*, as she entered the exhibit with her daughter and fellow model, Lila Moss. "He was so generous with his passion." Likewise, Naomi Campbell shared her thoughts on the designer after working with him as a muse: "If I could describe our relationship, it was fun, witty, intelligent, never a dull moment, so creative, risk-taking and caring," she said. "He was very honest: He did not suffer fools." Much the same, during 2011's "Alexander McQueen: Savage Beauty", many of the late designer's biggest supporters, muses and collaborators showed up in droves including Daphne Guinness and Shalom Harlow.

Power pairings are the name of the game for designers at the Met Gala. Whom one arrives with can be used to say so much – from the support of a new campaign star to a new direction in branding. Marc Jacobs walked the red carpet at the 2017 "Rei Kawakubo/Comme des Garçons" exhibition with his then-campaign star, Frances Bean Cobain, and her mother, Courtney Love. Who could make a more powerful statement for a theme about all things avant-garde?

In recent years too, one muse isn't enough for designers involved with the Gala. Curating a group of people who fit a theme and convey a specific narrative is what it's all about. Take, for example, former creative director of Gucci, Alessandro Michele, who attended with long-time muses Dakota Johnson, Charlotte Casiraghi and Jared Leto in 2016. Likewise, then-Valentino designers Maria Grazia Chiuri and Pierpaolo Piccioli took Lorde, Lily Collins, Zoë Kravitz and Miles Teller to the same event.

Some designers are simply more prominent than others at the Met Gala. Whether it has to do with co-chairing the event, consistently having a table of influential celebrities on their side, or creating some of the most memorable and splashy looks, there are decidedly a handful of designers who have become regulars – those you expect to see and those you know will be creating some of the most fantastic creations of the entire evening.

131

# JEAN PAUL GAULTIER

**Since the beginning, Jean Paul Gaultier has been known as a provocateur of fashion, one who takes dramatic silhouettes to new heights with grandiose proportions.**

And even though the designer officially retired in 2020, the brand is still flourishing and pumping out Met Gala outfits for the next generation. One of the most memorable Gaultier looks of all time was when supermodel Linda Evangelista stepped out at the 2004 "Dangerous Liaisons: Fashion and Furniture in the Eighteenth Century" event in a gilded dress with a red trim and cape straight from the Jean Paul Gaultier Spring 2004 couture show. Part-kimono, part-ballerina tulle concoction, Evangelista was the perfect person to pull off the high-fashion gown. "There are so many things that look like other things. You can't tell what they are from a distance," the designer said of the collection when it was first presented during Paris Fashion Week.

Designers at the Met Gala often serve as the ultimate manifestation of brand identity and muse. Think: when Gaultier attended the ball with Madonna, his longtime muse, in 2018. The singer-actress wore a black gothic get-up complete with corset and ballgown. Gaultier previously dressed her in the mid-1980s for the premiere of *Desperately Seeking Susan*, during her iconic *Blonde Ambition* Tour in 1990, and again for her *Confessions* Tour in 2006.

132

The iconic Jean Paul Gaultier dressed his longtime muse, Madonna, in 2018.

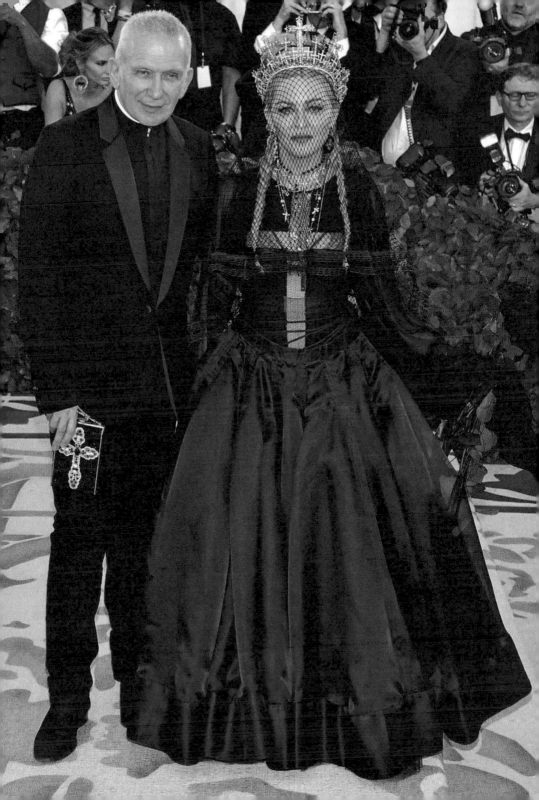

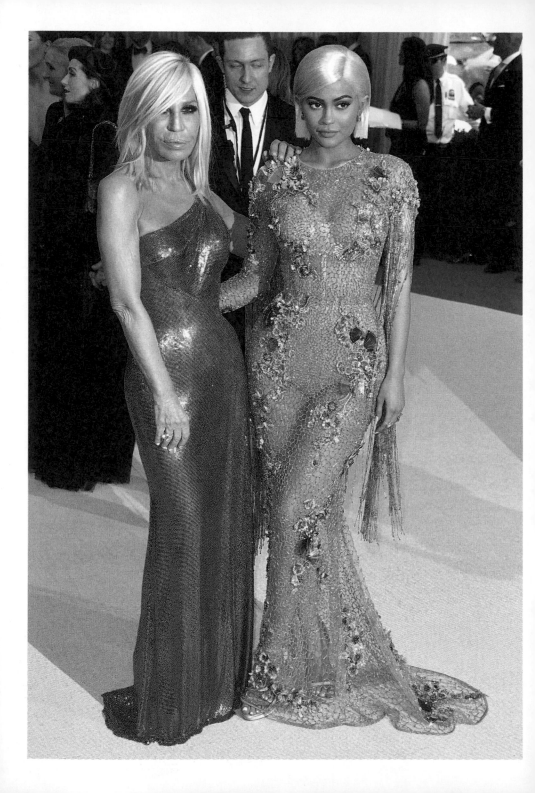

# DONATELLA VERSACE

**Arguably, there's no other designer who has been as involved with the Met Gala as Donatella Versace. Or, rather, the Versace brand in its entirety.**

Almost as soon as Anna Wintour took over the event, The Costume Institute celebrated the work and life of Gianni Versace (brutally murdered the same year in 1997) with the Gianni Versace Gala, chaired by philanthropist Julia Koch, chairman of Fairchild Publications, Patrick McCarthy, with Elton John and Donatella as honorary chairpersons. But even before that, tastemakers like Naomi Campbell were wearing Versace creations on the red carpet at the Met Gala and elsewhere.

During 1996 and early 1997, Donatella took over much of the decision-making for the Versace brand while Gianni Versace was recovering from cancer, and she was also his natural successor following the designer's murder. She debuted her first collection for Atelier Versace for Spring/Summer 1998. The lavish and opulent haute couture show, true to Donatella's aesthetic, took place on a see-through catwalk held over The Ritz hotel's swimming pool in Paris.

135

In recent years, Versace has dominated the Met Gala with A-list guests to rival any other fashion house. Consistently, the brand delivers eye-popping looks that stay true to the aesthetic of the brand, but also wow beyond words with a clear vision into the theme and the world of Versace.

Versace has dressed some of the most notable icons, in looks that are standout above all else: Kylie and Kendall Jenner, Lil Nas X, Anne Hathaway, Dua Lipa and Blake Lively among others.

# THOM BROWNE

**Even though Thom Browne hasn't been around as long as many of the household brands that dominate Met Gala coverage, the designer has still made just as much of an impact on the scene, with his own extremely directional, boundary-pushing style.**

In 2001 Browne started his label, with a focus on tight, short grey suiting and the emblem of red, white and blue stripes. Previously, he tried his hand at acting before working at Giorgio Armani as a salesman and later Club Monaco, then owned by Polo Ralph Lauren.

For the past few years, Browne has dressed some of the world's A-listers for the Met Gala in variations of his classic aesthetic with a highly whimsical, experimental angle. Jenna Ortega, Olivia Rodrigo, Janelle Monae and Pusha T were just a few of the guests at the Thom Browne table in 2023. Monae wore one of the most avant-garde looks of the evening – a structured cone-like tuxedo with mismatched black and white panels. In years prior, Browne dressed Lizzo in an extreme gilded cape piece, and Erykah Badu in a reinvented suit with a mesh face covering.

Perhaps Browne is intrinsically close to the Met Gala as he is the life partner of The Costume Institute's curator in charge, Andrew Bolton, and the two have lived together in New York City since 2011. In 2022, for his Spring 2023 show, Browne moved his fashion show which usually takes place in Paris to New York, pairing with his partner Bolton's "In America: An Anthology of Fashion" exhibition at the Met.

Neil Patrick Harris, David Burtka and Amy Fine Collins with Thom Browne on the Met Gala red carpet.

# KARL LAGERFELD

**No other designer has been as involved, worshiped and equally contested as Karl Lagerfeld when it comes to the Met Gala.**

In 2005, the Met played host to a large-scale Chanel retrospective as part of the annual exhibition and Gala. Designs from the 1920s onward created by Gabrielle Chanel were shown alongside Lagerfeld's own creations. Then of course, in 2023, The Costume Institute celebrated "Karl Lagerfeld: A Line of Beauty". For the first time since the Institute started doing bold exhibitions on solo designers, there was something of a major backlash on social media. Fashion fans expressed their distaste for the celebration of the designer, who had a history of making unsavoury statements about race, women, inclusivity and the #MeToo movement. A few publications also expressed the fact that the designer was problematic in that area. Still, it's impossible to ignore Lagerfeld's profound impact on the Met Gala and all the faces he dressed while under his reign at Chanel, Fendi and Chloé. It's easy to see his influence on the red carpet. Even in 2023, Nicole Kidman opted to wear a dress he designed in 2004 (which she already wore once in an infamous Chanel No.5 perfume commercial). A regular attendee at the Gala, Lagerfeld was seen at "Alexander McQueen: Savage Beauty" in 2011 and of course the Chanel exhibition of 2005.

For all the influence that Lagerfeld has had, he didn't believe in the idea of clothing being looked on as art, or displayed in a museum.

139

Karl Lagerfeld with Blake Lively on the Met Gala red carpet in 2011.

# ALEXANDER MCQUEEN

**Alexander McQueen (1969–2010) stands out as one of the few designers to have a retrospective exhibition tied to the Met Gala that later became one of the most-visited shows of all time at the Met.**

McQueen, who had an incredible career but a tragic and short-lived life, only attended the Met Gala once himself, with actress Sarah Jessica Parker in 2006. "Like Byron, Beethoven, and Delacroix, McQueen is an exemplar of the Romantic individual, the hero-artist who staunchly followed the dictates of his inspiration," curator Andrew Bolton wrote in the "Savage Beauty" exhibition catalogue. "As a designer, he doggedly promoted freedom of thought and expression and championed the authority of the imagination." Yet the brand lives on as a slew of celebrities (including Kaia Gerber and Bee Carrozzini, Anna Wintour's own daughter) continue to wear former creative director, Sarah Burton's, work. Especially with many of them opting for her designs to wear to the opening of the 2011 "Savage Beauty" exhibition which paid tribute to his work.

Alexander McQueen will always have an everlasting impact and influence on the Met Gala, simply by virtue of blowing away the expectations of attendance and mass interest in the art of fashion, as seen through the "Savage Beauty" exhibition.

140

Kaia Gerber at the Met Gala in 2022 wearing an Alexander McQueen dress designed by Sarah Burton.

# JOHN GALLIANO

**A flair for the dramatic has made John Galliano shine bright as one of the designers with the most unique contributions to the Met Gala.**

In 2004, he dressed the model Amber Valletta in a get-up that perfectly suited the over-the-top rococo theme of "Dangerous Liaisons: Fashion and Furniture in the Eighteenth Century". She wore a corset, a heavy tiered and ruffled skirt and a wig to rival Marie Antoinette. "Looking back on it, I think it's so badass that I went for it, because it was at a time when people were just starting to get into the theme," Valletta told *W* magazine. "That was a cool moment to be pushing the envelope."

A controversial figure known for a history of offensive comments, in the times Galliano has attended the Met Gala, he has often dressed as provocatively as his muses. In 2006, he styled actress Charlize Theron in a burgundy dramatic draped gown. The designer in turn wore snakeskin cowboy boots, sequinned jeans, a red polka-dot vest and an ornate velvet embroidered jacket. In a world where men rarely dress eccentrically on the Met Gala red carpet, it was an enormous departure from the norm. The look Galliano wore himself was named one of the most memorable Met Gala menswear looks of all time by *GQ* magazine, who declared that it "might be the riskiest fit ever to hit the red carpet".

143

Galliano is the only person to have dressed Princess Diana for the Met Gala too, when he worked at Dior. He dressed her in a navy-blue slip dress in 1996.

John Galliano with muse and fashion favourite, FKA twigs.

# MARC JACOBS

**Jacobs is one of those designers intrinsically associated with the Met Gala. And every time he attends the event, no matter what, he makes a bold statement, whether it's how he dresses or who he's with.**

Take, for example, when he attended the Gala opening for "Schiaparelli and Prada: Impossible Conversations" in 2012. Instead of wearing a tuxedo, he opted for a sheer, lace black button-down dress designed by Comme des Garçons. Underneath, he wore a pair of white boxer shorts and also styled the look with some black socks and pilgrim shoes. "I just didn't want to wear a tuxedo and be boring," he told the Met Gala livefeed. "I think Miuccia Prada is such a celebration of the unconventional and so it felt like, appropriate, somehow. [Schiaparelli and Prada] are two women that I have always loved the work of. I mean, Schiaparelli is one of my all-time heroes and Miuccia Prada continues to be a hero of mine. I am just looking forward to seeing the exhibition."

The designer has also gained a reputation for bringing some of the most iconic guests as his plus-one. In 2015, at the Gala to celebrate "China: Through the Looking Glass", he walked the red carpet with none other than Cher. Naturally, the Gala is rife with A-list celebrities, but the singer was particularly special as a guest to a designer as it had been almost 20 years since the last time she attended in 1997, when she arrived on the arm of Donatella Versace.

Marc Jacobs surprised everyone when he brought Cher to the Met Gala in 2015.

# MIUCCIA PRADA

**As one of the few female designers to be honoured in a Costume Institute exhibition, through "Schiaparelli and Prada: Impossible Conversations" in 2012, Miuccia Prada is intrinsic to the small circle of most important designers associated with the Gala.**

She has also served as a co-chair several times: in 1998 for "Cubism and Fashion" and in 2012 for the aforementioned "Schiaparelli and Prada: Impossible Conversations" show. Of course, beyond that, she's a frequent attendee of the Gala, walking the red carpet with her signature Prada looks. Few designers manage to capture such an essence and distinct personal style as she does. In 2023, for example, she wore lime green satin pants and matching heels with a lemon-yellow top with a Mandarin collar and chunky gilded necklace. Yet nothing can compete with the outfit she wore to the "Heavenly Bodies: Fashion and the Catholic Imagination" Gala of 2018. Instead of doubling down on ecclesiastical regalia, she wore a neon highlighter-green sequinned-fringed polo and matching midi skirt with silver heels. She held her crystal clutch to her chest – a pose that she's often seen doing (clasping her jacket together) as she takes the final bow at her runway shows. Her look decidedly said, "Welcome to the Church of Prada."

The celebrities Miuccia Prada dresses for the Met Gala are instantly recognizable for their persistence in staying true to their personal style.

147

Celebrities dressed by Prada often wear incredible, heavily embellished pieces that are intrinsically true to the Prada universe.

# BOB MACKIE

**Even if his name doesn't resonate, you've seen his influence through some of the most iconic looks in Met Gala history.**

Bob Mackie basically invented the naked dress when he walked Cher down the red carpet in 1974, dressing her in a shimmering nude sheer dress trimmed with feathers. "She was never intimidated by anything that I ever put on her," he told *Town and Country* magazine.

Elsewhere, the sheer, revealing glittering dresses seen all over the red carpet, from Beyoncé to Rihanna to Kendall Jenner may not bear his name, but they do bear his influence. In 2023 alone, Amber Valletta, Karen Elson, Gigi Hadid, Billie Eilish, Amanda Seyfried, Suki Waterhouse and Rita Ora wore some version of a naked dress. The designer also somewhat unintentionally was involved with one of the Gala's most controversial dresses of all time. In 2022, Kim Kardashian walked the Met Gala red carpet wearing Marilyn Monroe's original 1962 Jean Louis gown, in which the iconic actress famously sang "Happy Birthday" to President John F. Kennedy. Mackie drew a sketch for the original gown in his early career working as an assistant to Jean Louis. "I thought it was a big mistake," he told *Entertainment Weekly* of the Kardashian choice of outfit. Like many others who showed their outrage online, Mackie echoed historians' concerns that wearing the gown would cause damage to its preservation and structural integrity.

Cher and Bob Mackie represent the designer-muse partnership almost better than anyone else.

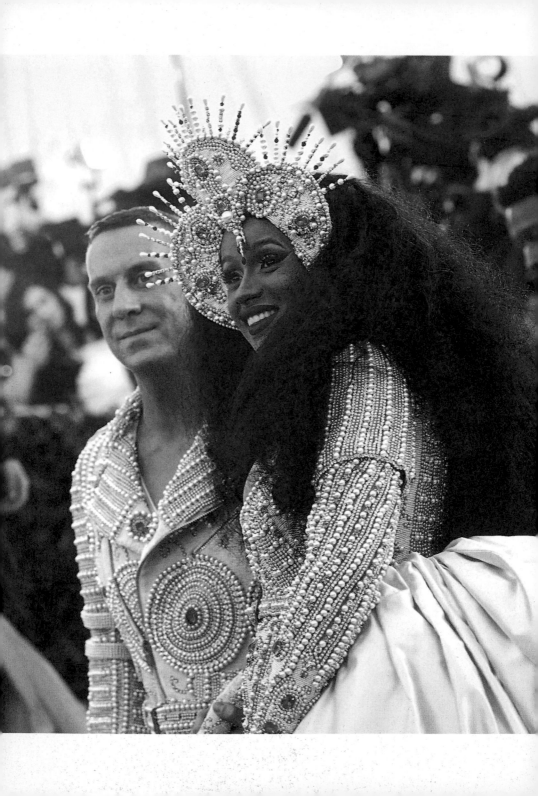

# JEREMY SCOTT

**No matter which way you look at it, Jeremy Scott has created some of the most iconic Met Gala fashion of all time. True to his original aesthetic that bears no rules, he experiments with every material and every idea imaginable – truly bringing humour and irony to the forefront of fashion. Scott served as the creative director of Moschino from 2013 until 20 March 2023, and in that role, dressed everyone from Cardi B and Katy Perry to Bella Hadid and Devon Aoki, all for the Met Gala.**

When it comes to Katy Perry, Scott has designed some of his most boundary-breaking looks for her. Think: a light-up chandelier, and walking cheeseburger, both of which were the perfect fit for the queen of kitsch. Scott is never scared to go overboard and takes real risks with his Met Gala looks, pushing forward the idea of clothes as art and vice versa. "Katy so genuinely speaks my language, not only on a visual and creative level, but on a human level," Scott explained of the duo's partnership. "She really is someone I admire as a friend, as an artist, as a performer and as a human. I've been so thrilled to be a part of her journey." His Met Gala looks could easily be considered some of the most extreme to ever walk the red carpet.

In 2019, he matched Bella Hadid in a gemstone covered outfit, and in 2018, he matched a pregnant Cardi B in all her glory – both of them wore pieces heavily embellished with opulent pearls. Scott has designed over 50 different Met Gala looks.

151

Jeremy Scott with Cardi B at the 2018 Met Gala, echoing the opulent aesthetic of "Heavenly Bodies: Fashion and the Catholic Imagination".

# THE
# MEMORABLE
# LOOKS ...

# MAKING HISTORY

**The most memorable looks of the Met Gala cross the boundaries of culture, taste and art. They create conversations, and even more importantly, they make us question our own point of view.**

Sometimes, an incredibly beautiful look that respects the theme isn't enough. And other times, a splashy look that crosses into gimmick territory can do the trick when it has an angle that's intellectual enough. Certainly, there's been a fair share of celebrities who have moved into wearing items more like costumes than traditional red-carpet eveningwear. Think Katy Perry, Lady Gaga and Jared Leto, for example.

Some designers have been quick to call out the phenomenon too. "The only thing about the Met that I wish hadn't happened is that it's turned into a costume party," designer Tom Ford has said. "That used to just be very chic people wearing very beautiful clothes going to an exhibition about the 18th century. You didn't have to look like the 18th century, you didn't have to dress like a hamburger, you didn't have to arrive in a van where you were standing up because you couldn't sit down because you wore a chandelier." Nevertheless, the Met Gala is about risk-taking fashion. And the people want to see something that will shock, excite and inspire them – or make them think – even on the most basic level.

154

Previous: Gigi Hadid wearing an epic Versace look.

Opposite: Cardi B at the 2019 Met Gala in a custom, feathered Thom Browne look with a structured bodice, a bejewelled headpiece, feathered shoulders, sheer gloves and half a million dollars in ruby nipple covers.

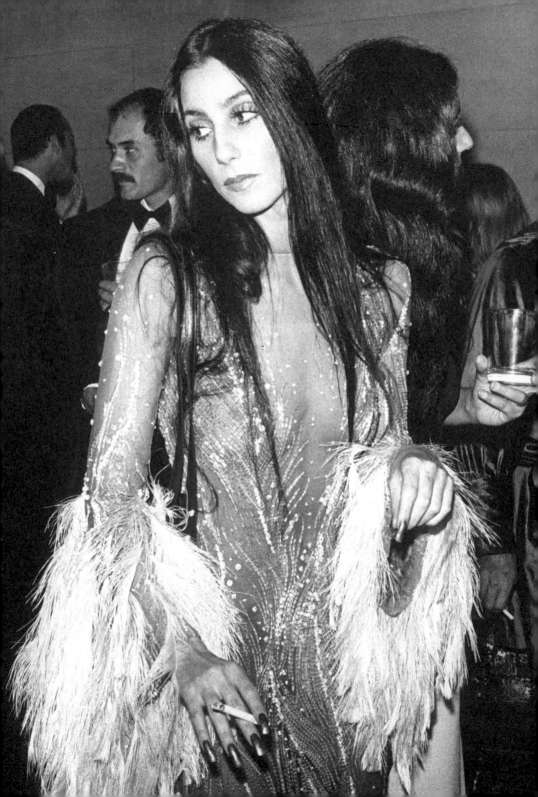

# CHER
# IN BOB MACKIE, 1974

**Beyoncé, Jennifer Lopez and so many other celebrities who have all donned the naked dress owe some part of the inspiration behind it all to Cher, an early adopter of the naked look.**

Frequent collaborator and designer Bob Mackie often dressed the singer and his creation that she wore in 1974 turned heads and caused a bit of a cultural reset. The gown in question was a sheer beaded dress, with white feathered sleeves and a matching white feathered skirt. Everything was visible: yes, *everything*. Incredibly scandalous at the time, Cher later wore the same dress in a photograph which appeared on the cover of *TIME*.

"In those days, *TIME* reserved its covers for world leaders or someone who invented something important, like a vaccine," Mackie told *Vogue* in 2017. "Then there was Cher on the cover in that incredible piece of clothing, and newsstands sold out of it almost immediately. Some cities even banned it from being sold – it's funny considering how some stars can barely keep their clothes on today."

157

## "All of a sudden celebrities were coming up to Cher and telling her, 'We were inspired by your dress!' And they'd go online and look at all these old outfits of hers I designed."

*Bob Mackie*

Cher wearing the naked dress that started it all.

# BIANCA JAGGER
# IN HALSTON, 1974

**The It-girl who often frequented Studio 54, Bianca Jagger was also a noted muse of the designer Roy Halston Frowick.**

When she chose a red sequinned halter-neck dress for the 1974 edition of the Met Gala, it was total embodiment of the designer and muse relationship – so much so that over half a century later, this look often makes the list of Best Met Gala Looks of All Time. With Mick Jagger on her arm and her jacket casually flung over one shoulder, she represented the quintessential casual rocker party-girl in a sea of socialite celebrities who were more buttoned-up. Opting for minimal make-up and hair, she nailed the look with a matching embellished beret and jacket.

158

**"I am someone who believes in style. I don't believe in fashion. I wear what I think looks good on me; my style is the same as it has always been. I have clothes from 40 years ago, fortunately, I can still wear a lot of them,"**

*she told* **Elle UK** *in 2023.*

Bianca Jagger's Halston look is unforgettable because it didn't conform, but rather stood out on its own.

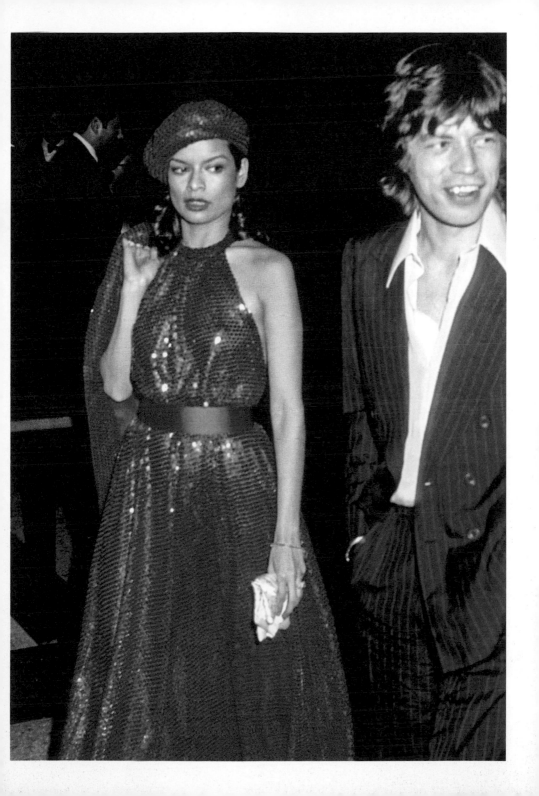

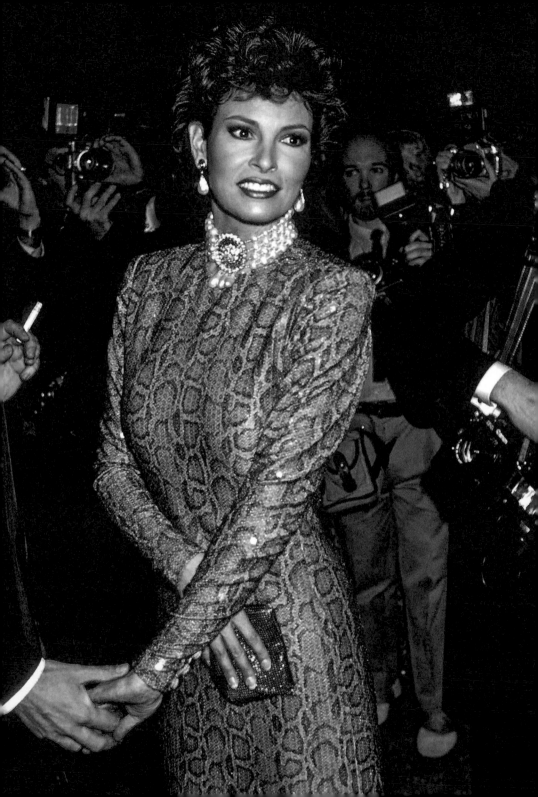

# RAQUEL WELCH IN THIERRY MUGLER, 1982

**The year was 1982, and the theme was "La Belle Époque".**

For the occasion, the legendary actress, who most notably starred in *One Million Years B.C.* in 1966, wore a ruched bodycon dress designed by Thierry Mugler. It was the era of the French designer and the time of a very particular kind of bodycon, and who better to represent it than Welch.

Part of Welch's allure was her total embodiment of glam, too, which she created through the make-up and hair which went along with her red carpet looks. "My mother was one of those old-fashioned ladies who would never dream of letting the neighbours see her in rollers, so that is kind of the way I am," she told *Allure*. "If I'm going to leave the house, I have to put myself together. I will put on a little bit of eyeliner, a little blusher, a little lip gloss. It means you made a little bit of effort to face the world. You need a little armour or protection. Part of the art of being a woman is to know make-up."

161

## "I was not a sex image for men. I was a sex image for women."

*Raquel Welch*

Sometimes the accessories make the look too – like the giant earrings and pearl choker seen here.

# NAOMI CAMPBELL IN VERSACE, 1995

**It was 1995, and the fashion supermodels ruled the world.**

Naomi Campbell wore a dazzling, glittering silver dress by Versace and posed alongside her fellow models and friends, Kate Moss and Christy Turlington. The look was iconic not just because it was a gorgeous dress, but because it also represented a unique moment in time as well as the distinct personal style of the supermodels and the roles they each played in fashion during this decade.

**"I loved this dress. It was slim-fitting and body hugging and it just glistened. I remember when I saw this dress for the first time, I thought to myself, 'Wow, Gianni, is that for me?' It seemed like one of those dresses that you read about in those fairy tale books, you know?"**

*Naomi Campbell*

Naomi Campbell and other supermodels from the same time period would often wear the work of the designers they collaborated with most, on the runways and in campaigns.

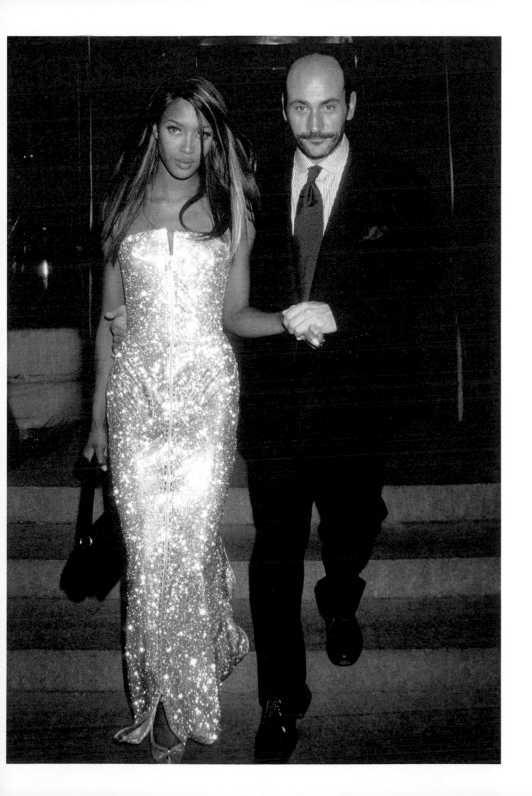

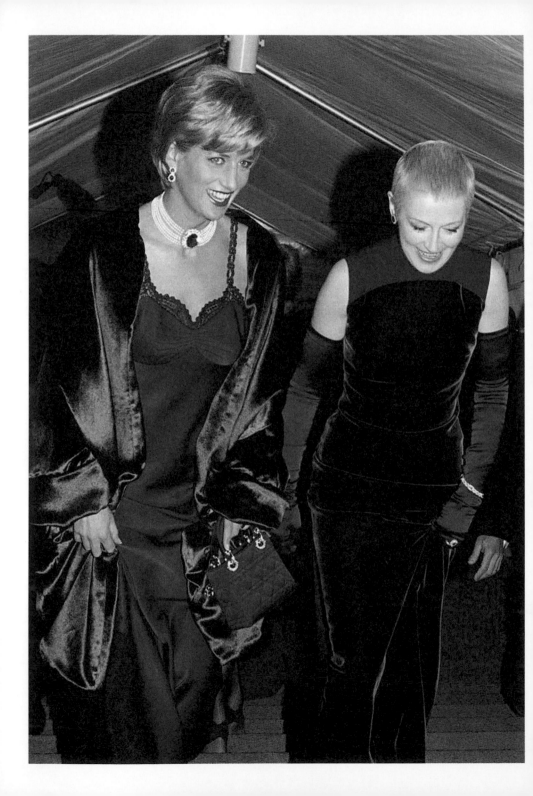

# PRINCESS DIANA IN DIOR, 1996

**Diana, Princess of Wales, attended the Met Gala only once, but her influence did not go unnoticed.**

That year, The Costume Institute was celebrating the work of Christian Dior and she opted for a simple, clean, floor-length navy-blue slip dress. Some would argue the power of the look was all in the accessories – she wore her iconic pearl and sapphire choker, and, of course, the quilted little top-handle Dior bag debuted the previous year. It would ultimately be named after her, as the "Lady Dior" bag. And while her dress – from John Galliano's debut haute couture collection for Dior, topped with a robe coat – was iconic, it wouldn't have made nearly the same impact without the Princess's little odes of personal style done through careful accessorizing.

Just two years earlier, Princess Diana made headlines everywhere as she emerged from a car in what the press called her infamous "revenge dress" – a little black dress worn to the Vanity Fair party for the Serpentine Gallery in 1994. She wore the dress the same night Prince Charles' tell-all interview about his infidelity aired on television.

165

Princess Diana cemented her Met Gala look with her signature iconic pearl and sapphire choker.

# SALMA HAYEK
# IN VERSACE, 1997

**It was the late '90s, and Salma Hayek and Gianni Versace had reached a unique fever pitch of obsession worldwide.**

The actress wore a runway look from Gianni Versace's last collection, capitalizing on her wardrobe of effortless slip dresses with a twist. Hayek was in an era of wearing minimalistic slip dresses, following her history of opting for suits on the red carpet. "I didn't have any connections," the actress told *W* magazine of her earlier red carpet fashion choices. "The only connection I had was to somebody I knew at Hugo Boss, so I wore a man's suit because no one else gave me anything to wear," she explained. "I'm Mexican. I'm also very short, which doesn't help with the weight and doesn't help with the design," she also told *Vogue India*. "But you know, I was ingenious. I took chances."

166

## "You have to learn how to dress. It's a science,"

*Hayek told the* Standard.

Her genius lay in wearing totally boyish suits or simple sexy slip dresses.

# LIV TYLER IN STELLA MCCARTNEY, 1999

**What's the most revolutionary thing you can do for a black-tie event when the theme is "Rock Style"?**

Go casual. And so they did. Rock royalty combined as the actress Liv Tyler (daughter of Aerosmith's Steven Tyler) and designer Stella McCartney (daughter of The Beatles' Paul McCartney) walked the red carpet together in DIY tops that read "Rock Royalty". They might not have been wearing couture gowns, but each lived the theme.

According to the designer, she found out about the theme the night before. The morning of the big event, she brought a three-pack of Hanes tank tops (a personal favourite of McCartney's) to the vintage rock 'n' roll shop Filth Mart in Little Italy to get the pieces customized. The design was created on the spot, with studs and ribbons. McCartney wore hers with a pair of Chloé trousers that she designed – she was the head of the French house from 1997 to 2001. Tyler paired hers with a long black maxi skirt from Comme des Garçons. The dichotomy of the high and low, combined with the unplanned ease of coolness gives these Met Gala looks a big dose of unexpected rebellion.

169

Taking a risk – when it works – pays off in the best possible way when it comes to the Met Gala red carpet.

# LIL' KIM
# IN VERSACE, 1999

**The American singer and rapper is the blueprint for so many today.**

Lil' Kim's style is expressive and one-of-a-kind, and she took a lot of fashion risks that pop culture icons replicate to this day. Take, for example, in 1999, when she was dressed by Versace in a hot pink monochromatic look. Her mink fur outerwear was a one-off, while the pastel python boots came directly from the runway and the rest of the outfit consisted of fuchsia studded hot pants with a matching bra. Her hair was custom-streaked to match in brilliant pink, baby pink and blonde. This was her interpretation of the year's "Rock Style" theme and it will forever be looked at as a source of inspiration.

"Donatella is my girl. We've loved each other from the moment we first saw each other," she told *Vogue*, in 2020. "At the Met, you're a designer's muse [and] she loved the fact that I have fun in her clothes. Versace was one of my favourite designers. She knew that and would always create things tailor-made just for me." Speaking about the Gala and how it has changed over time, she said: "It's so different now than it was then. The Met was almost like a secret society, not everyone got invited. It was this upscale, elite society event."

Lil' Kim often worked with the visionary fashion stylist Misa Hylton to create her visionary and ground-breaking outfits. Hylton was also the designer and stylist for the infamous purple jumpsuit and pasty that Lil' Kim wore to the 1999 VMAs.

A long-term style icon to many, Lil' Kim's Met Gala look is a favourite of fans because it distilled her unique style down to one incredible look.

# CAROLINE KENNEDY IN CAROLINA HERRERA, 2001

**Caroline Kennedy epitomized glamour on her way to the 2001 Met Gala – "Jacqueline Kennedy: The White House Years" – wearing a strapless white Carolina Herrera gown with matching elbow length opera gloves.**

For an exhibition celebrating the old money luxury aesthetic of Jacqueline Kennedy, she nailed the look. The satin white opera gloves, the cropped little bob hairdo and the chunky shining statement earrings – each was a tribute to the masterclass of Jackie O's style.

An unexpected wildcard for fashion lovers, she has turned out many surprising looks for the Met Gala. She was one of the few to wear a very extreme Comme des Garçons outfit to the 2017 "Rei Kawakubo/Comme des Garçons: Art of the In-Between" opening.

173

## "I think people had a sense of her style but probably didn't understand how well-read and interesting she was,"

*Caroline said of her mother,*
*Jacqueline's sense of fashion.*

Caroline Kennedy is one of the few political figures to make a fashion splash at the Met Gala over the years.

# SARAH JESSICA PARKER IN ALEXANDER MCQUEEN, 2006

**In 2006, Sarah Jessica Parker, known for dressing to the theme with every fibre of her being, attended the "Anglomania: Tradition and Transgression in British Fashion" Gala with designer Alexander McQueen in matching tartan creations.**

It was a rare moment for both the designer and the celebrity – and showed a different side of McQueen, especially with the matching outfits. "Like everybody else, I was in love with him," the actress told *Vogue*. "I have every pin he dropped from his mouth in my possession still. I have everything he cut off in my possession still. I have things that seem like nothing, from every fitting I ever did with him in my possession."

174

**"When I was invited, I said out loud, 'I wish I could go with Lee' – we called him Lee,"**

*Parker explains.*

Sarah Jessica Parker may have executed her dedication to theme best in 2006.

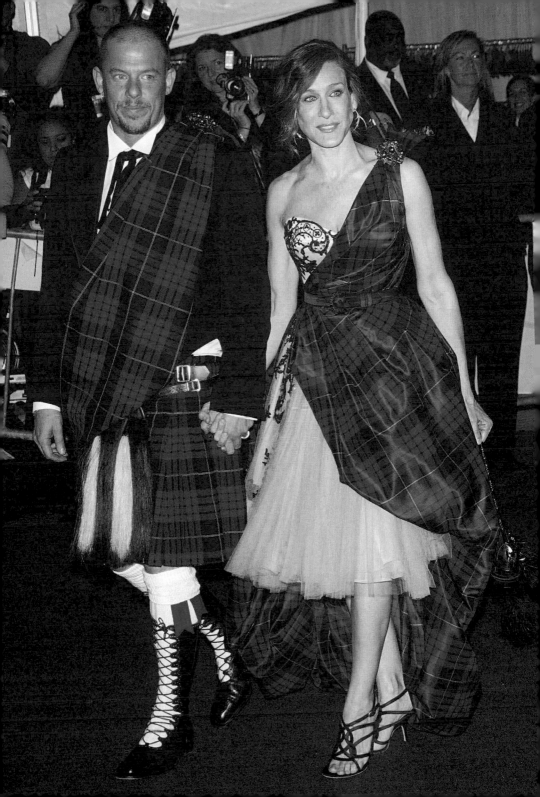

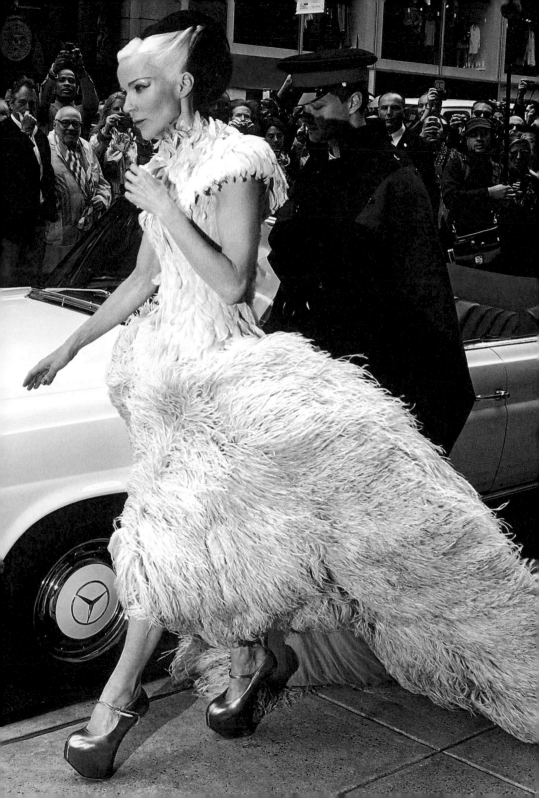

# DAPHNE GUINNESS IN ALEXANDER MCQUEEN, 2011

**Daphne Guinness is not a Met Gala regular but when she does attend, she goes all out.**

The heiress attended the "Alexander McQueen: Savage Beauty" Gala to honour the late designer, a dear friend to her. She put on a performance, too. Crowds watched during an eight-minute show at Barneys New York – part of a series of events featuring her getting dressed at the store – that featured Guinness striking poses on a lucite table and through backlit panels showing her silhouette as she got ready for the Gala. She emerged in her Met Gala gown, the finale dress from Sarah Burton's second solo collection for Alexander McQueen – a striking feathered plumed creation in shades of ethereal white and grey.

"There's been this discussion for longer than I've been alive that fashion is not art", she told the *New York Times*. "My feeling is that this is another piece of evidence that, yes, there is a commerical side to fashion that is needed, but there are these crossover moments that do become art."

177

Designer and actress Daphne Guinness made history when she made a performance out of getting dressed for the Met Gala – dressing up for a live audience before "get ready with me" videos were a thing on social media.

# LILY COLE IN VIVIENNE WESTWOOD, 2013

**For a legendary designer with such influence, there's been a stunning lack of Vivienne Westwood featured at the Met Gala, on celebrities as well as in the exhibitions.**

In 2013, the Met Gala celebrated the "PUNK: Chaos to Couture" exhibition – which also showed very little of Westwood's work. She walked the red carpet, and she dressed her friend and muse, model Lily Cole, in a gorgeous oversized ballgown with a shimmering skirt. The large skirt paid tribute to Westwood's archival style – a fascination with big skirts. It was made of Amazonian wild rubber, with full tulle skirt and a black underskirt. "I hope turning rubber into couture is just the beginning of what can be done," said the English model of her dress. "I feel very proud to be joining the woman who redefined punk as couture in a dress made from trees!" The corset was based on a seventeenth-century style corset but oversized at the neckline, which modernized it and gave it a shape so specific to Westwood's world.

"She was an independent thinker who drank art, literature and politics through one straw and blew bubbles of ideas, designs and theories into the world through another," Lily Cole wrote of Vivienne Westwood, in *Vogue*, after her passing in late 2022.

178

Fellow activists Lily Cole and Vivienne Westwood were a match made in heaven at the 2013 Met Gala.

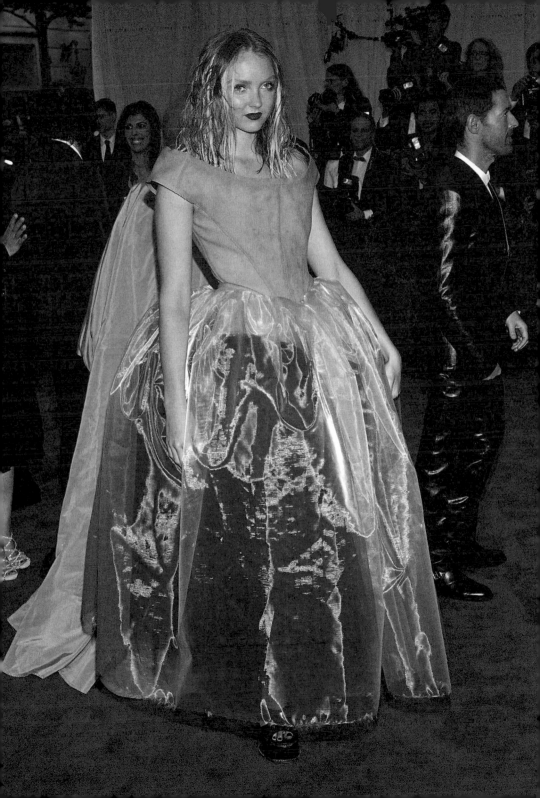

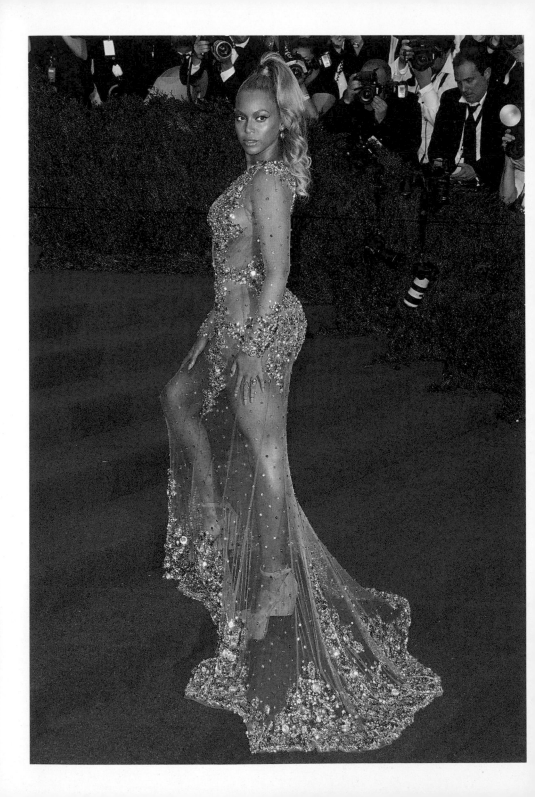

# BEYONCÉ
# IN GIVENCHY, 2015

**Taking a page from the naked dress playbook, the iconic singer-songwriter Beyoncé chose a custom Givenchy sheer gown in 2015 that stunned.**

She wore the barely-there gown with an open back and transparent train. As the last one to walk the red carpet, she obviously caused a scene. Ty Hunter is the celebrity stylist behind her standout outfits worn at the Met Gala over the years. According to her stylist, he did not leave her side during the evening because the dress was so heavy. "As light as it looked – she looks like she's butt naked, but she's not – it was the heaviest dress," he told *Business Insider*. "Normally, I get her to the front, she goes off, and then I'll sit down somewhere. But this night, I never really left."

Beyoncé rarely, if ever, gives interviews or talks in-depth about her work or what she wears, making her Met Gala outfits all the more interesting.

181

**"I grew up in the fabric store. My mother would say, 'Come on, let's go to the fabric store,' and she would make all these beautiful clothes for myself and the other ladies of Destiny's Child,"**

*she told* CNN *in 2011.*

Beyoncé's outfits will always surprise since she doesn't always attend the Gala and often shows up late to build anticipation.

# CHLOË SEVIGNY IN J.W. ANDERSON, 2015

**Actress Chloë Sevigny is one of New York City's most iconic It-girls of all time, for her unexpectedly freeing wardrobe choices.**

For the 2015 edition of the Met Gala, she wore a dragon embroidered set by J.W. Anderson. Some were quick to criticize her choice, calling it too much. "O.K., the theme was China, but did it have to go this far?" a *New York Times* reporter wrote. But the look perfectly captured the raw personal style of a Downtown icon. Sevigny was labelled the Coolest Girl in the World by *The New Yorker* when she was just 19 years old in 1994. "When I'm walking the red carpet all I can think about is the criticism," she told the *Standard.* "When I was growing up, if you're wearing a certain thing you were really standing for something and it was easier to identify what people were standing for or were into music-wise or scene-wise. How you dressed was more of an indication of that and your attitude towards it. Now it's very hard to tell. It feels like everyone is just posturing", she has told *Elle* of her personal style.

182

## "I just feel like every time I come to Hollywood, I'm dressed like a weirdo,"

*Chloë Sevigny told* **Who What Wear.**

Actress-model Chloë Sevigny opts for the unexpected – and that's why people love her style.

# CLAIRE DANES
# IN ZAC POSEN, 2016

**Every memorable look has some element of fantasy. It's a gala after all and there has to be some magic to inspire the vision to dream.**

Zac Posen and actress Claire Danes did just that in 2016. From afar, the gown resembled Disney princess attire brought to life in a spellbinding strapless silhouette done in powder blue. But Danes and Posen had a little trick under their sleeves: custom French organza woven with fibre optics for a light-up effect, powered by 30 mini battery packs sewn into the lining of the gown. In total, the masterpiece took 500 hours to make. "I went through a sequence of stages throughout the process of draping this gown, playing with motion and structure to capture the emotional engineering. The gown is hollow underneath with no tulle, [so it's] holding its own structure," the designer said.

185

**"Zac literally had a bus for me to get here, so I stood. I'm moving carefully ... cautiously. I'm going to throw the afterparty under my dress! It's very spacious,"**

*Danes told* **Vanity Fair.**

Like a digital princess come to life, Claire Danes' dress lit up when the room was dark.

# RIHANNA IN MAISON MARGIELA, 2018

**Only Rihanna could rival the Pope on the red carpet. In 2018, she stunned in a white outfit inspired by the opulence of Catholic vestments.**

Think: a heavily bejewelled gown layered underneath a flowing overcoat from Maison Margiela by designer John Galliano. Saints, sinners and everything else in-between, Rihanna showed fashion's faithful desire for art-worthy creations that recontextualize the everyday. The dress was dramatic enough, but with the bishop's hat designed by the milliner Stephen Jones, the whole vision was taken to a completely new level. In total, the outfit took 250 hours to sew and 500 hours to hand embroider by Maison Margiela Atelier in Paris. "It feels expensive; it's heavy," Rihanna said in an interview with *Vogue* on the red carpet. "It's designed by John Galliano and we've had a few different fittings; we've had a few colours. They beaded this by hand... It would be a sin not to wear it."

Perhaps most memorable was the headpiece. It was reminiscent of papal tiaras worn by popes from the medieval era until the mid-1960s. According to the *New York Times*, "The last papal tiara – a bejewelled, three-tiered gold and silver number worth at least $15,000 – was worn in 1963 by Pope Paul VI." An incredibly rich symbol for the star of one of the most lavish parties on earth seems fitting.

186

Rihanna's 2018 look was hand-beaded and provided a decadent nod to the theme.

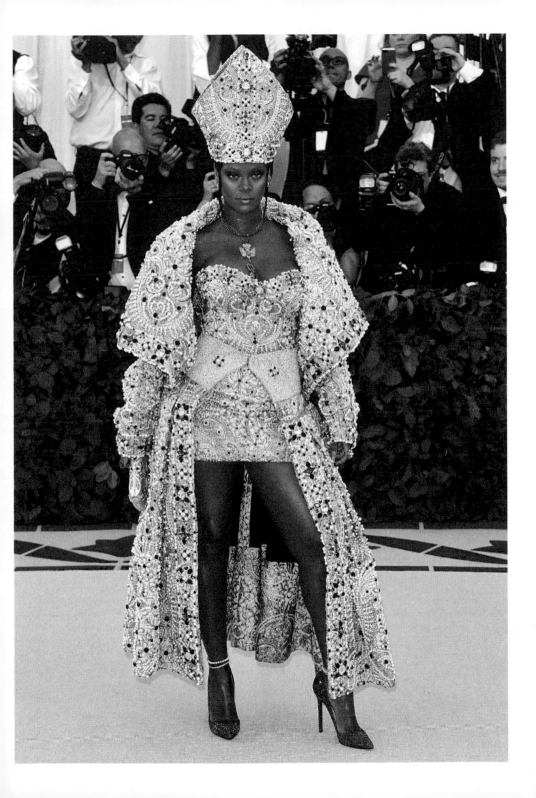

# LANA DEL REY
# IN GUCCI, 2018

**Sometimes, an outfit is even more memorable in Met Gala history when the person who is wearing it isn't a regular.**

Such is the case for Lana del Rey's 2018 look. The singer arrived in a celestial white gown with a heart chest plate filled with tiny daggers and a halo headpiece with bluebird's wings for a surrealist effect. It was a take on "Our Lady of Sorrows", the depiction of the Virgin Mary when portrayed sorrowful and in tears. Flanked by Gucci's creative director at the time, Alessandro Michele, and actor and musician Jared Leto, who bears an uncanny resemblance to Michele, the trio represented an eclectic, maximalist work of walking art.

"This is the genius behind everything," said Jared Leto on the red carpet, as he gestured to Michele. "Who better for tonight's theme than an Italian designer who's a very devout Catholic?" Michele was inspired by authentic historical pieces. "I'm a very big collector of a lot of old pieces like this, so it's so fun," he told *Vogue*.

189

## "Fashion is inspired by youth and nostalgia and draws inspiration from the best of the past,"

*Lana Del Ray in an interview with* **Vogue UK.**

Lana Del Rey's Met Gala outfit of choice was effortlessly on brand for the singer-songwriter.

# KATY PERRY IN MOSCHINO, 2019

**For Katy Perry, Queen of Kitsch, having a run-of-the-mill gown at the Met Gala was out of the question but she certainly developed the concept further when she wore a dress that resembled a chandelier by Moschino creative director Jeremy Scott.**

More than just a campy ensemble that shocked, the gown required six weeks of carefully placing thousands of Swarovski crystals, plus the installation of a working light fixture consisting of a corset made of 18 steel bones and two hidden battery packs to illuminate the lights. "Who has ever been to a ball that did not have a chandelier?!," Scott said at the time. "The idea of elegance itself is quite camp and I wanted to play with that concept, poke a lil fun at it with a loving nudge." Scott said the look was supposed to be "rich and austere, like a fancy old-money mansion," which was an easy feat for someone who has designed over 50 different Met Gala looks to date.

190

## "It was fashion satire,"

*Perry told* Vogue, *of the cheeseburger outfit she then changed into after she walked the red carpet in the chandelier look.*

Singer-songwriter and TV personality Katy Perry has worn some of the most extreme looks of all time to the Met Gala.

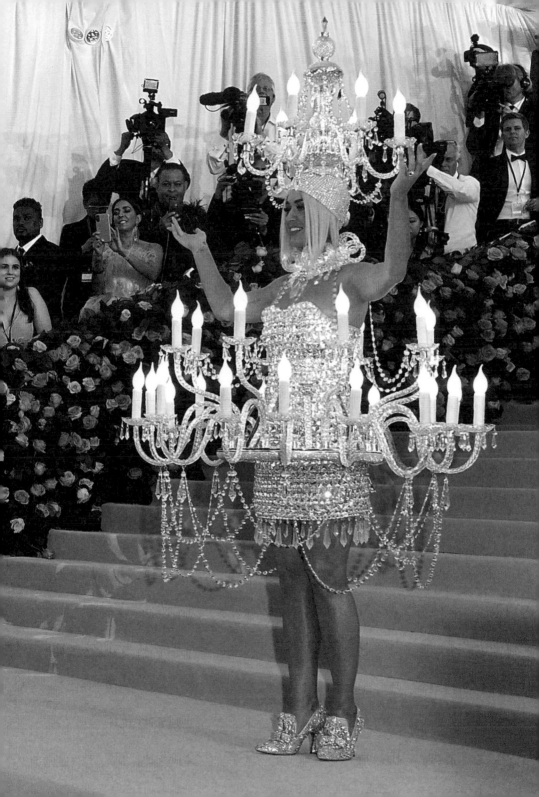

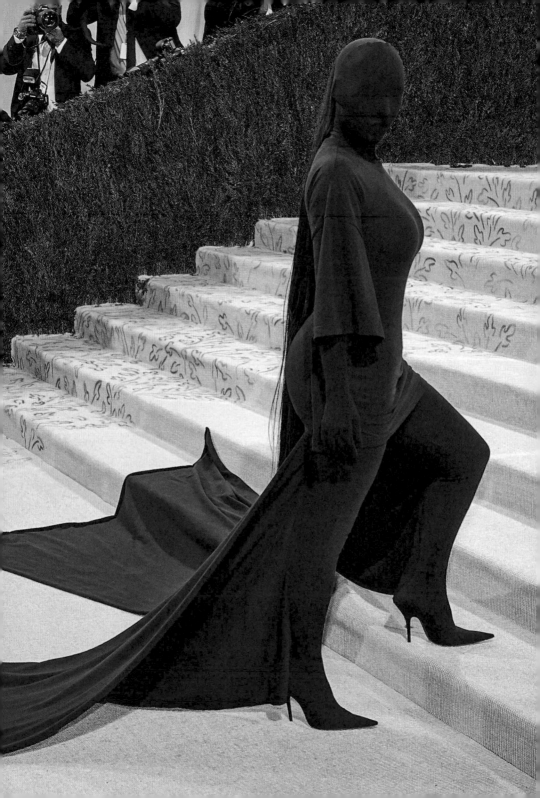

# KIM KARDASHIAN IN BALENCIAGA, 2019

**Love her or loathe her, reality star Kim Kardashian's Met Gala looks are pure genius because they get people talking and cause anyone to rethink fashion and the traditional notions of red carpet.**

And in 2019, she did just that, trading her famous face that raised America through reality television, for anonymity. She wore a haute couture black gown that covered her from head to toe – quite literally – designed by the Balenciaga designer Demna. The only hint of revelation was the Kardashian family nearby, plus her famous long hair, which came through the top of the mask – and of course, that infamous physique. In a cover interview with *Vogue*, Kim revealed, "I fought against it. I was like, I don't know how I could wear the mask. Why would I want to cover my face? But [Balenciaga creative director] Demna and the team were like, 'This is a costume gala. This is not a *Vanity Fair* party where everyone looks beautiful. There's a theme and you have to wear the mask. That is the look'."

193

## "What's more American than a T-shirt head to toe?!"

*Kim Kardashian*

Kim Kardashian's 2019 Met Gala look will go down in history as one of the most surprising choices.

# LADY GAGA IN BRANDON MAXWELL, 2019

**Vogue called it the greatest Met Gala entrance of all time, and for good reason.**

In 2019, for the "Camp: Notes on Fashion" Gala, singer-songwriter (and now actress) Lady Gaga turned her red carpet into a multi-outfit immersive event for everyone involved, seamlessly setting a new bar for fashion that transforms into a performance. She started by gallivanting down the New York City sidewalks, three blocks to the Metropolitan Museum of Art in a flowing Brandon Maxwell cape dress with a 25-foot train, complete with five men dramatically holding umbrellas and her train.

Once on the pink carpet, she took off the pink cape to reveal a black structured gown with puffed bustle on the side, again shedding her dress to reveal a bodycon hot pink gown. As a team primped her, she removed the dress yet again to reveal her final look: black sequinned underwear with fishnet tights. She toted around a wagon full of pink cowboy hats before lying down on the stairs and posing some more.

"What I really love about what we're doing is that it reads like an essay or a poem and it tells a story," Gaga told *Vogue*. "It's so in line with Susan Sontag's notes. I feel that it's intelligent and I feel it's also very innocent in a lot of ways." The red carpet had never seen anything like it.

When Lady Gaga attended the Met Gala in 2019, Anna Wintour reportedly broke her own rule of staying inside the museum to watch Gaga's 16-minute performance.

# QUANNAH CHASINGHORSE IN PETER DUNDAS, 2021

**The Oglala Lakota and Han Gwich'in model, activist and land protector Quannah Chasinghorse attended the 2021 Met Gala wearing a golden Peter Dundas gown with cut-outs, a cascading train and turquoise jewellery.**

For that year's theme, "In America: A Lexicon of Fashion", she represented one of the few Indigenous people at the Gala, interpreting the event to portray her own roots, with her distinctive look and her traditional face markings. As a guest at the Gala and an insider in the fashion industry, you can always count on her to uplift the Native community and voices in a way that is distinctly her own. "It's extremely important to represent and bring authentic and true American culture to this year's theme, as Native American culture has been appropriated and misrepresented in fashion so many times," Chasinghorse (seen left) told *Vogue*. "Reclaiming our culture is key – we need to show the world that we are still here, and that the land that everyone occupies is stolen Native land." She also complimented turquoise and silver pieces that reflected her ties to the Navajo tribe.

197

"I wanted to complement the dress with Navajo jewellery," breakout model Quannah Chasinghorse said of her outfit.

# KIM KARDASHIAN
## IN MARILYN MONROE'S ARCHIVAL DRESS, 2022

**Perhaps no other dress in the history of the Met Gala has caused quite so much controversy and discussion as it did in 2022 when media personality Kim Kardashian wore a historic and fragile dress that once belonged to Marilyn Monroe.**

She decided to borrow the same crystal spun gown that Monroe wore to sing "Happy Birthday" to US President John F. Kennedy in 1962. Designed over 60 years ago by Hollywood label Jean Louis, with help from Bob Mackie, the dress was loaned to Kardashian for the Met Gala, under the agreement that no alterations were permitted.

Kardashian wore the dress only on the stairs of the red carpet, barely able to walk because it was so tight. She posed for photos, before changing into a replica for the rest of the event. It was also, reportedly, the most expensive outfit (excluding jewellery) ever worn to the Gala, weighing in at over $5 million. After the event, photos of damage to the dress went viral, but the company that loaned the dress has insisted that the damage existed before she wore it. Elsewhere, videos showed Kardashian trying to squeeze into the dress and barely fitting into it. It caused a debate for the ages: should historical, museum-worthy clothing be worn?

Reality star Kim Kardashian is the only major celebrity to have worn an extremely valuable historical garment to the 2022 Gala, causing much controversy in the gown custom-made for Marilyn Monroe.

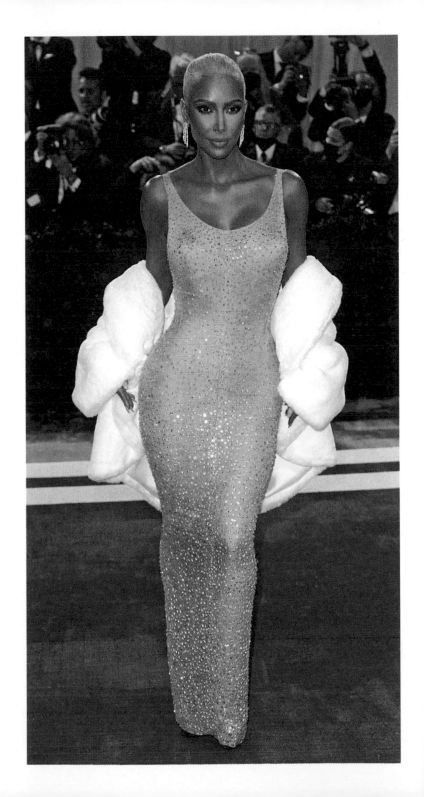

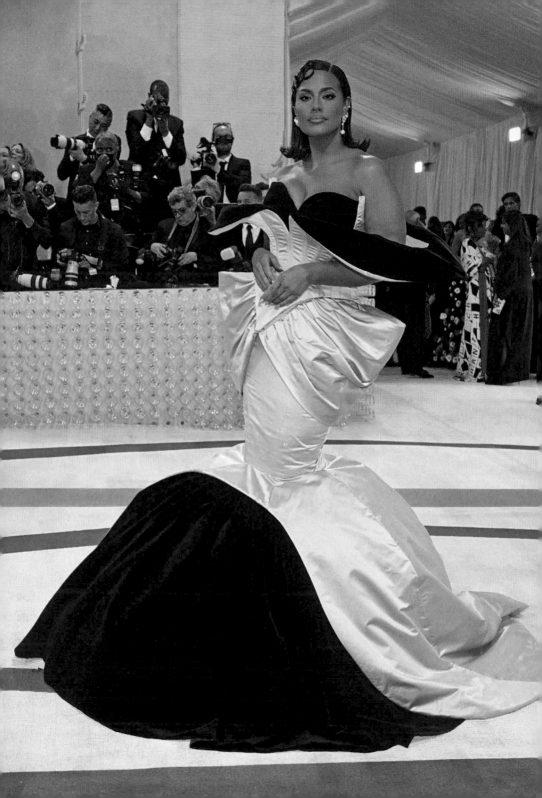

# ASHLEY GRAHAM
# IN HARRIS REED, 2023

**Few celebrities wear less established designers on the red carpet for the Met Gala, but Ashley Graham did so in 2023 and it turned out to be one of the most memorable looks for the ages.**

The model wore a pink sculpted dress that was equal parts eighties Chanel haute couture and Jetsons. Rising London-based designer Reed, who also spent time as a creative director for Nina Ricci, puts body diversity at the forefront and that was also one of the reasons why Graham selected him.

"You could see especially after the Nina Ricci show that he really cares about body diversity," she told *Vogue*. "And to know that a designer that has that many eyes on him, that has that much control now is making a point to say, 'I want more curves on the runway,' for me, that's a big deal." Graham refused to fade to the background in black and white, instead opting for pink and took up space with intent and purpose.

"Ashley is, for me, the American supermodel. She's the American curve icon," Reed told *Vogue*. "I think especially in Karl's [Lagerfeld] work, he's had such an extraordinary career but it's a little bit sad that there is a lack of body diversity there. For me, with the theme and working with someone like Ashley [Graham], we can give a new story to his [Karl Lagerfeld's] work and we bring a beautiful curvaceous storyline that I don't think has been present in past Chanel."

201

Ashley Graham's gown mixed old and new and stood out as one of the most unique Met Gala creations of 2023.

# MICHAELA COEL
# IN SCHIAPARELLI, 2023

**The Black Panther: Wakanda Forever star and co-chair of the Met Gala for 2023 took a forever red-carpet classic – the naked dress – and transformed it with an eye on the future of style.**

Her nude, transparent Schiaparelli dress dripped with 130,000 crystals, 26,000 mixed stones, and it took over 3,800 hours of work to create. It was a power play to experiment with the idea of jewellery as clothing at a time when "quiet luxury" was all over the headlines.

The gown and its crystalline accessories, as well as gilded pearls, stars and lips, made an opulent statement. Designed by Daniel Roseberry, who joined French haute couture house Schiaparelli as creative director in 2019, the dress showed a different side of art and fashion as well as spotlighting Roseberry's work for the next generation of big red-carpet players.

202

**"On the day of the Met, we spoke a bit about the dress, but really just about our lives, our human flaws," Coel told _Vogue_. "I found myself able to be really open with Daniel. It didn't scare him away."**

Daniel Roseberry of Schiaparelli is changing the language of the red carpet with his unique point of view, as seen on actress Michaela Coel.

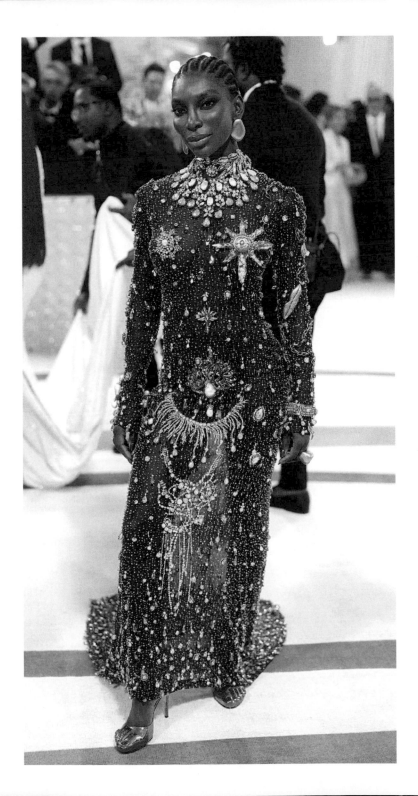

# INDEX

205

207

# CREDITS

The publishers would like to thank the following sources for their kind permission to reproduce the pictures in this book.

Alamy: Abaca Press 58; /Associated Press 16, 70; /Nathaniel Noir 30; /Doug Peters 84

Getty Images: Selcuk Acar/Anadolu Agency 73; /Selcuk Acar/NurPhoto via Getty Images 80; /Axelle/Bauer-Griffin/FilmMagic 180; /Kena Betancur/AFP 79; /Evan Agostini 57, 103, 172, 175; /Neilson Barnard 92; /Neilson Barnard/Getty Images for Barneys New York 176; /Jonathan Becker/Contour by Getty Images 21; /Larry Busacca/Getty Images 88, 116, 119, 120; /Mike Coppola 95; /Richard Corkery/NY Daily News Archive via Getty Images 89; /George DeSota/Newsmakers 54; /Dia Dipasupil/WireImage 8; /Steve Eichner/Penske Media 49; /Kyle Ericksen/WWD/Penske Media 37; /Charles Eshelman/FilmMagic 35, 65, 66; /Fairchild Archive/Penske Media 22, 28; /Billy Farrell/Patrick McMullan 63; /Noam Galai/Getty Images for New York Magazine 150; /Mitchell Gerber/Corbis/VCG via Getty Images 167; /Gotham 152, 155, 199; /Taylor Hill/WireImage 74-75, 76-77, 96, 108; /Ron Galella/Ron Galella Collection 27, 45, 99, 156, 159, 160, 163, 171; /Nick Haddow/Penske Media 46; /Rose Hartman/Getty Images 123; /Arturo Holmes/MG23/Getty Images for The Met Museum/Vogue 130; /Stan Honda/AFP 60; /Anwar Hussein/WireImage 164; /Taylor Jewell/Getty Images for Vogue 126; /Dimitrios Kambouris 12, 107; /Dimitrios Kambouris/Getty Images for The Met Museum/Vogue 100, 195; /John Lamparski 86-87; /Jon Levy 50; /Stephen Lovekin 138; /Stephen Lovekin/FilmMagic 179; /Kevin Mazur/WireImage 137; /Kevin Mazur/MG19/Getty Images for The Met Museum/Vogue 91; /Kevin Mazur/MG21/Getty Images For The Met Museum/Vogue 196; /Kevin Mazur/MG22/Getty Images for The Met Museum/Vogue 115; /Kevin Mazur/MG23/Getty Images for The Met Museum/Vogue 11; /Jamie McCarthy/FilmMagic 145; /Jamie McCarthy/MG21/Getty Images for The Met Museum/Vogue 33; /Patrick McMullan 25; /Nick Machalaba/Penske Media 38; /Sonia Moskowitz 24, 41; /Masato Onoda/WWD via Getty Images 83; /Cindy Ord/MG23/Getty Images for The Met Museum/Vogue 142; /Tony Palmieri/WWD/Penske Media 42; /Spencer Platt 69; /Roy Rochlin/Getty Images 146; /Alexi Rosenfeld/GC Images 14; /Mari Sarai/Wireimage 169; /John Shearer 134, 203; /John Shearer/Getty Images for The Hollywood Reporter 187, 191; /Jim Spellman/WireImage 53; /Karwai Tang/WireImage 184; /Andrew H. Walker/Getty Images for Variety 183; /Theo Wargo/WireImage 112, 141, 192; /Angela Weiss/AFP 200; /Sean Zanni/Patrick McMullan 111, 133

Shutterstock: Walter Sanders/The LIFE Picture Collection 19